IMAGES
of America

AROUND
MOUNT WASHINGTON

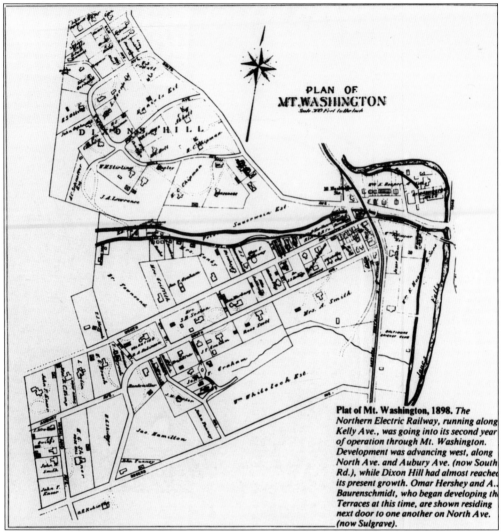

PLAN OF
MT. WASHINGTON
Scale 300 Feet to the Inch

Plat of Mt. Washington, 1898. *The Northern Electric Railway, running along Kelly Ave., was going into its second year of operation through Mt. Washington. Development was advancing west, along North Ave. and Aubury Ave. (now South Rd.), while Dixon Hill had almost reached its present growth. Omar Hershey and A.J. Baurenschmidt, who began developing the Terraces at this time, are shown residing next door to one another on North Ave. (now Sulgrave).*

PLAT OF MOUNT WASHINGTON, 1898. This plat appeared in the Bromley Atlas of Baltimore County. The Northern Electric Railway, running along Kelly Avenue, was going into its second year of operation through Mount Washington. Development was advancing west, along North and Aubury Avenue (now South Road), while Dixon Hill had almost reached its present growth. Omar Hershey and A.J. Baurenschmidt, who began developing the Terraces at this time, are shown residing next door to one another on North Avenue. (Author's collection.)

ON THE COVER: HAPPY HILLS. Children at Happy Hills Convalescent Home were literally taken outside for fresh air and sunshine to help improve their health. When the weather was not suitable for outdoor sunshine, simulating sunshine from the ultraviolet rays of an electrical quartz lamp was found to be an excellent Vitamin D substitute. Dr. Benjamin Tappan, medical head of the Baltimore institution, indicated that the machine worked wonders in curing rickets and other childhood ailments. Dr. Tappan stressed, "Of course, this machine does not take the place of sunshine, but it is very valuable in giving children vim, vigor, vitality and Vitamin D." (Courtesy of the Mount Washington Pediatric Hospital.)

IMAGES
of America

AROUND
MOUNT WASHINGTON

Linda Noll

ARCADIA
PUBLISHING

Published by Arcadia Publishing
Charleston, South Carolina

Printed in the United States of America

Library of Congress Control Number: 2013935331

For all general information, please contact Arcadia Publishing:
Telephone 843-853-2070
Fax 843-853-0044
E-mail sales@arcadiapublishing.com
For customer service and orders:
Toll-Free 1-888-313-2665

Visit us on the Internet at www.arcadiapublishing.com

This book is dedicated to my family for their support and encouragement during the writing of this book.

CONTENTS

ACKNOWLEDGMENTS

Thanks go to all Mount Washington residents who answered my request for advice, historical information, and photographs. I am grateful for the following people's assistance during this project: Paul Levine, Charlene Abeln, Chuck Bennett, Carol Berkower, Elizabeth and Edward Grove and sons Walter and Benjamin, Gail Freedman, Robin Klein, Elizabeth Liebow, Alice Mack, Cecilia Meisner, Dana Schock-Spana, and Dr. Carol Schreter. Thanks go to Bryce Butler; David Conn; Myles Norin, for the article in the *Mount Washington Newsletter*; Maayan Jaffe, editor, for the article in the *Jewish Times*; and Amy Davis, *Baltimore Sun* reporter, for her assistance. I extend a special thank-you to Dr. Denise Moreault for her insight and guidance throughout the writing process. I thank my family for their encouragement, advice, and assistance during the writing of this book.

Thanks also go to the following people who provided vintage photographs and historical information to be used in this book: Phil Golden, director, and Kathy Ullrich, activity director, Springwell Senior Living Community; Kathleen Lee, director of public relations, Mount Washington Pediatric Hospital; Mark Miller, author of *Mount Washington, Baltimore Suburb*; curator Mark Dawson, dispatcher Jerry Kelly, Dennis Falter, Robert Jansson, and Alan Schneider at the "Gentlemen's Club" at the Baltimore Streetcar Museum; Doug Munro, St. John's Church; Chris Shafer, Walter Schwab documents and photographs; general manager John Cadigan and member Carol Greene, Meadowbrook Aquatic & Fitness Center; Linda Boswell, Chris Brooks, and Bernetta Palasik, Shrine of the Sacred Heart Church; Alison Foley, associate archivist, St. Mary's Seminary & University Archives; Rev. Karen Davis and secretary Mary Ellen Cassanego, Mount Washington-Aldersgate United Methodist Church; Principal Sue Torr, the Mount Washington School; Elizabeth Di Cataldo, the Bryn Mawr School for Girls; director of administration Pat Whitehead and volunteer Jo Keller, Waldorf School of Baltimore; Betsy Laucks, marketing and communications director, Baltimore Clayworks; volunteer Paul Umansky and communications coordinator Noel Lloyd, Sinai Hospital; Lone and Martin Azola and family, Ruscombe Mansion; Pikesville-area photographer Gerald Yamin; Virginia Felter and Estelle Kahn, Pimlico area; Beryl Frank, author of *A Pictorial History of Pikesville, Maryland*; Diana Harbaugh, director of promotions, Maryland Jockey Club; Melissa and Steve Heaver, Fire Museum of Maryland; Capt. Jason Turner, Glen Avenue Fire Station; and Claire Pierson, Jewish customs and traditions.

Last, but not least, I extend a special thank-you to the following dedicated staffs at various institutions who researched and scanned photographs for this book: researcher-selector Richard "Shylock" Parsons and webmaster-technology specialist Jason Domasky, Baltimore County Public Library Legacy Website; Charlie Plantholt, Baltimore Streetcar Museum; Catherine Dunkes, Baltimore Museum of Industry; and volunteer archivist Joe Finn, the Lacrosse Museum and National Hall of Fame. Thanks go to Mrs. T. Newell Cox Sr., Robert Bruce Hamilton Jr., and Herbert H. Harwood Jr. for their wonderful photograph collections and for their foresight in donating them to the Baltimore County Public Library for future generations.

INTRODUCTION

The town of Mount Washington has evolved from humble beginnings as a 19th-century mill town into a peaceful, suburban retreat from city life. The area that later became Mount Washington began with the grant of 786 acres from Charles Calvert to Edward Stevenson, a Baltimore County farmer, in 1703. Stevenson further enlarged the parcel in 1705 to include another 144 acres and sold it to Robert Boone of Arundel County, whose family was one of the first families in the area.

The area remained largely unsettled until about 1810, when the Washington Cotton Manufacturing Company constructed the first cotton mill in Maryland, driven by waterpower from the Jones Falls river. The mill soon became a major employer in the area, attracting workers and their families. However, the lack of passable roads—Falls Road was not built until 1904—delayed significant growth in the community. The earliest noteworthy settlement in the area was that of mill workers who settled in two rows of brick dwellings along Smith and Forge Avenues and Oliver Street in the vicinity of the mill. This area around the mill became known as Washingtonville, believed to have been named after a tavern on Falls Road, and predates Mount Washington by some 40 years. In 1830, the advent of the Baltimore & Susquehanna Railroad, afterwards merged into the Northern Central, brought new changes to the area.

At the same time, a new upper-class neighborhood emerged across the tracks from Washingtonville. In 1854, just prior to the Civil War, real estate investor George Gelbach began to market real estate lots under the name of Mount Washington Rural Retreat. Gelbach advertised his development as a place for men in Baltimore's affluent classes who could afford the luxury of commuting to their downtown businesses and back again to their spacious period homes in the evening. Gelbach's ambitious suburb evolved slowly and remained primarily a summer and weekend retreat until after the Civil War. By 1882, outlying areas were developed by noted architects and builders such as Thomas Dixon, a renowned architect of Mount Vernon Methodist Church in Baltimore, who promoted Dixon Hill located between Smith and Kelly Avenues. A small community of African Americans also settled into detached and semidetached houses and organized two churches nestled in the area. A section north of Western Run, named Clover Hill, was part of a 19th-century estate owned by John Kelso, who also owned the Washington Cotton Manufacturing Company. Charles Carroll and his Baltimore Company patented other areas, such as Hill Top Park and Pill Hill, as the Labyrinth in 1752.

With rail transportation at their doors, businessman set up trade shops, such as shoe repairs, hardware, farm supply and grocery stores, and smitheries, by the 1880s. The railroad also encouraged other institutions to relocate to the country. In 1856, Rev. Elias Heiner built the German Reformed Church and the Mount Washington Female College on Smith Avenue, which was later sold to the Sisters of Mercy who established Mount St. Agnes College in 1898. Other religious institutions, such as the Shrine of the Sacred Heart Catholic Church, St. John's Episcopal Church, Mount Washington Presbyterian Church, and Mount Washington United Methodist Church, offered more choices for their new residents.

By the early 1900s, Mount Washington had grown from a summerhouse community to a thriving, year-round suburban community that offered the best of both worlds to its residents. The Baltimore and Northern Streetcar Company's opening of a single-track line on Western Run Road (now Kelly Avenue) in 1897 promoted further development in the area. Mount Washington was annexed by Baltimore City in 1919, and more changes followed. Automobile traffic increased through the 1920s, and the Kelly Avenue viaduct opened in 1927 to relieve the congestion at Smith Avenue and Falls Road. The streetscape further changed when streetcars were removed in the late 1940s, and Kelly Avenue was widened between Greeley Avenue and Cross Country Boulevard for bus traffic. Automobile ownership soared in the 1950s, and most of the early-19th-century Washingtonville homes were razed to make room for more progress, the Jones Falls Expressway.

Although part of Baltimore City, Mount Washington's beautiful wooded lots, winding roads, and spacious homes provide country living for Mount Washington residents, with schools, churches, caring facilities, recreational open spaces, and a vigilant improvement association. The families in the area walk to the shops, restaurants, and salons in Mount Washington, and some walk to church and work. Instead of driving down the Jones Falls Expressway, one can board the light rail into the city just as residents took the Northern Central or streetcar downtown in the 1880s. What attracted people to this area in the late 1800s still holds true for today.

Neighboring communities such as Pimlico and Pikesville had different origins and were closely tied to the migration of the Jewish population from downtown areas and the construction of the Pimlico Racetrack. Although Jews had been living in Baltimore as far back as the 1780s, it was not until the 1830s that Jews left Eutaw Place and headed north to develop communities in Pimlico and Pikesville. In the early 20th century, Jewish immigrants to the Baltimore area first formed enclaves in East Baltimore, not far from Johns Hopkins Hospital, in neighborhoods known as Broadway East, Jonestown, Middle East, and Oliver. During World War II, the Jewish community migration began in earnest; however, Jews still retained ownership of the neighborhood businesses in their old communities up until the time of the Baltimore riot of 1968. By the late 1930s, Park Heights Avenue and Reisterstown Road, all the way to the city line, became one large Jewish neighborhood with kosher grocery stores and delicatessens, clothing stores, dry cleaners, restaurants, country clubs, synagogues, and schools. Many of the region's largest and most established synagogues and Jewish schools are located in or near Pikesville. In the past few decades, the Jewish community has expanded even farther outside the city to the more distant suburbs of Owings Mills and Reisterstown.

One

EARLY SCENES OF WASHINGTONVILLE AND MOUNT WASHINGTON

The milling industry played a definitive role in the birth of the community of Washingtonville, the first settlement in the area. Some records indicate that the name was derived from a tavern on Falls Road. Thomas Fulton, the mill's first owner during the pre–Civil War era, provided employment for the Washingtonville residents on Forge Avenue off Falls Road. Forge Avenue ran from Oliver Street to the railroad tracks and was the main street of the community. The two-story brick houses built along Forge Avenue reflected the design of homes in various industrial communities in Baltimore during the first half of the 19th century. Most were comprised of four rooms, and there was no sewage until about 1940. Regardless of the crowded conditions, some homeowners rented rooms to other factory workers. Records indicate that the Washingtonville community lasted for about 140 years. The construction of the Jones Falls Expressway in 1958 pushed residents from their homes with $3,200 in hand. Only one semidetached house reminiscent of those early years of cotton duck manufacturing at the Washington Cotton Mill remains standing at 1405–1407 Forge Avenue. Chrome, iron ore, and copper mining were prevalent in the area of Bare Hills on Falls Road as well as rock quarrying on Greenspring Avenue. Various mining tycoons settled their families in Washingtonville and nearby communities of Cylburn and Cold Spring.

In contrast, real estate developer George Gelbach envisioned this area as a "rural retreat" for businessmen who traveled by train to downtown and back again in the evening to their homes. These new residents built spacious period homes as summer retreats, which provided an escape from the heat and noise of the city for their families. The railroad encouraged entrepreneurs who set up trade shops and grocery, hardware, and farm supply stores in the village. With further development in the late 1800s, the need for religious, educational, and recreational institutions arose. The advent of the streetcar and automobile and the improvements of roadways made travel in the community easier. It was just a matter of time before Mount Washington evolved from a summer retreat to a city suburb of year-round residents. The hills, streams, and stately homes beckoned homeowners to this ideal country setting in the city.

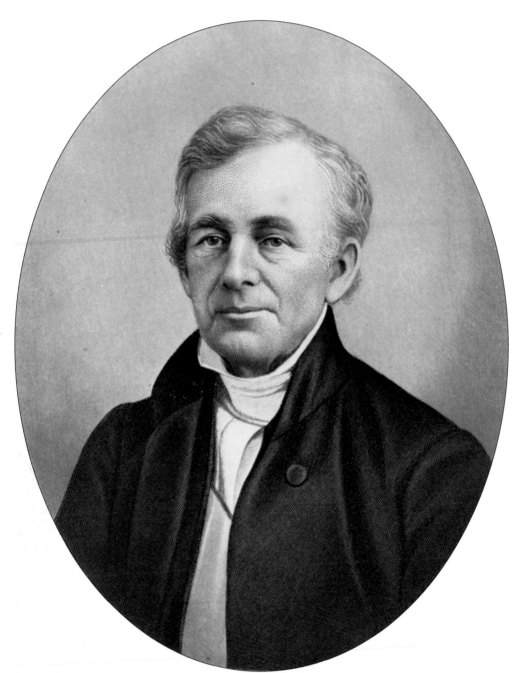

Isaac Tyson Jr. This is a portrait of Isaac Tyson Jr. (1792–1861), a Quaker businessman who created an industry that held a virtual monopoly of the world's chromium by the mid-19th century. He discovered the first deposits in the Bare Hills section in 1808. Tyson and his family were avid abolitionists before and during the Civil War. In 1864, his son James sent a Bible to Abraham Lincoln with the following postscript: "From a committee of colored men of Baltimore . . . as evidence of their regard and gratitude." (Courtesy of the Photograph Collection of the Baltimore County Public Library.)

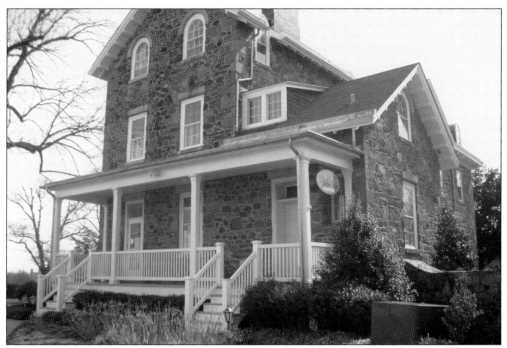

RUSCOMBE. In 1866, James Tyson, son of Isaac Tyson Jr., built this 2.5-story stone mansion on his 110-tract of land in the Melvale section of Baltimore County near his brother's Cylburn mansion. He named it Ruscombe ("brown hill") and lived there with his wife, Elizabeth Williams Dawson Tyson, and their seven surviving children (two had died in infancy) until 1879. He later sold the house and 37 acres to John LeMoyne, a lawyer from Chicago. (Author's collection.)

CYLBURN MANSION. Jesse Tyson, son of Isaac Tyson Jr., built this mansion in 1863 as a summerhouse for his mother and himself and named it Cylburn ("cool vale"). The mansion is a luxurious post–Civil War dwelling built of gneiss from Tyson's quarries at Bare Hills. In 1954, the Baltimore City Board of Recreation and Parks founded the Cylburn Wildflower Preserve and Garden Center. In 1982, the preserve was renamed Cylburn Arboretum. (Courtesy of the Photograph Collection of the Baltimore County Public Library.)

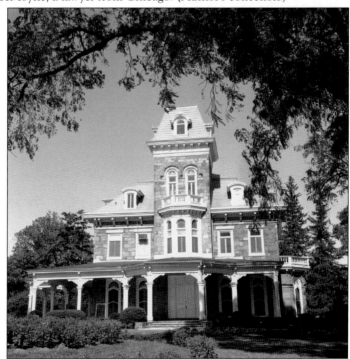

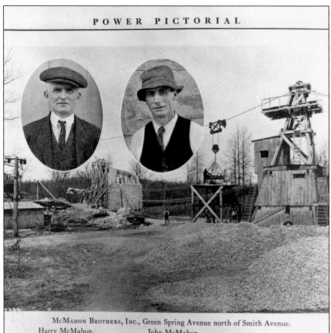

McMahon Brothers, Inc., Green Spring Avenue north of Smith Avenue.
Harry McMahon. John McMahon.

McMahon Quarry Works, 1925. The quarry works of the McMahon Brothers, Inc., was located at Greenspring and Smith Avenues. The company had just installed a 37.5-horsepower hoist at its new quarry. The inset photographs are portraits of Harry and John McMahon. The quarry area now known as Quarry Lake at Greenspring has been developed into a community of houses, condos, restaurants, retail outlets, and professional offices. (Courtesy of the Photograph Collection of the Baltimore County Public Library.)

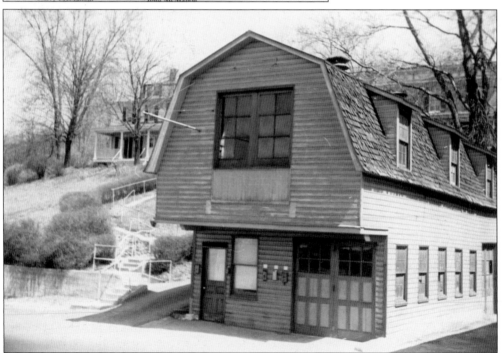

Blacksmith Shop on Falls Road. Earlum Buckley, a blacksmith from Rockland, came to Mount Washington on January 1, 1871, and took over the blacksmith shop at 5719 Falls Road, which was once operated by Milton Willey. Buckley's sons George and James joined him and operated under Earlum Buckley and Sons. In 1897, George built a new shop at 5721 Falls Road for his carriage-building trade. The property is now the site of a Pizza Boli's pizza and sub shop. (Courtesy of the Mount Washington School.)

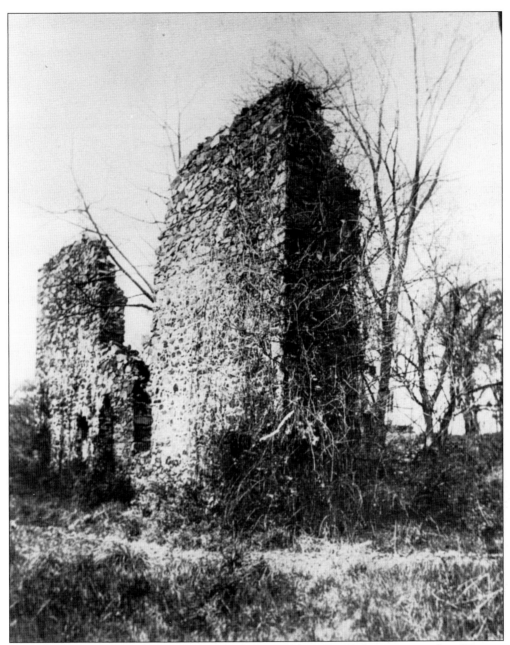

SNUFF MILL, C. 1900. These are remnants from an old snuff mill that once stood on Western Run, near the intersection of Greenspring Avenue and Pimlico Road, in the mid-1900s. Originally, the land was part of a tract owned by Charles Carroll of Carrollton, a wealthy landowner and signer of the Declaration of Independence. The snuff mill was part of a light-industrial complex at this location that later became known as the Pimlico Tobacco Works. The flood of 1868 damaged the mill property, and the ruins of this mill were later used as building materials for the construction of the Boy Scout Armory in 1911. (Courtesy of the Photograph Collection of the Baltimore County Public Library.)

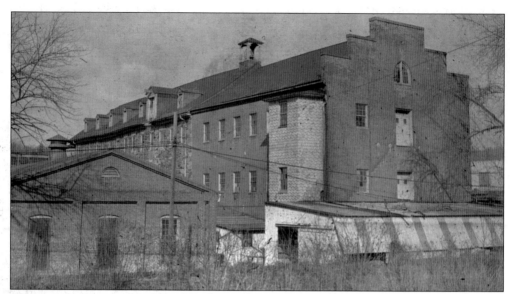

WASHINGTON COTTON MILL. In 1810, the Washington Cotton Manufacturing Company erected one of the first water-driven cotton mills in Maryland on a three-acre tract of land on Smith Avenue, near the Jones Falls, and was known as a maker of fine Irish woolens. During the 1820s, the mill marketed thousands of hanks of yarn weekly from a Baltimore warehouse. In the early 1860s, the Woodberry Manufacturing Company acquired the mill and produced cotton duck for sailmaking until 1918. In 1986, developer Sam Himmelrich Jr. bought the complex and by 1996 had converted it into a large retail complex. (Courtesy of the Photograph Collection of the Baltimore County Public Library.)

WASHINGTON HOUSES. In the early 1800s, mill workers and their families lived in row homes in the community of Washingtonville near the mill. These row homes were located on Washington Street, now known as Smith Avenue. All of the Washingtonville homes, with the exception of one duplex, were razed to make room for the Jones Falls Expressway in 1958. (Courtesy of the Mount Washington School.)

MARYLAND NUT AND BOLT PLANT. When the Washington Company textile mill closed, the Maryland Nut and Bolt Plant occupied the buildings on the seven-acre site on Falls Road prior to 1900. The company produced carriage bolts, hex and square lag screws, structural bolts, and a variety of other products. Locals referred to the business as "a mini Bethlehem Steel." American Chain and Cable owned the property from 1943 to 1972. (Courtesy of the Baltimore Museum of Industry.)

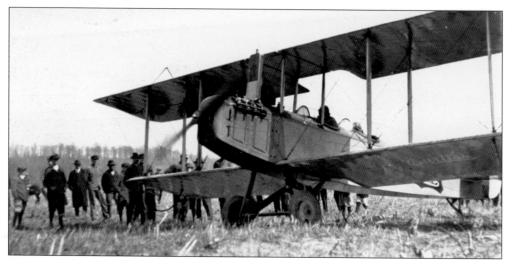

BIPLANE AT CURTISS-WRIGHT AIRPORT. A 270-acre million-dollar facility, Curtiss-Wright Airport was built at Greenspring and Smith Avenues in 1930. In May 1931, the first women's air show was held there. The headline in the *Baltimore Sun* newspaper read, "Women Bar Men at Tomorrow's Flying Carnival. Fair Sex Going to Monopolize Absolutely All of the Ten Events." Amelia Earhart, famous aviatrix, en route to the show, had to land at Willow Grove, Pennsylvania, when her plane developed trouble. (Courtesy of the Photograph Collection of the Baltimore County Public Library.)

READY FOR TAKEOFF. Curtiss Airfield straddled the Baltimore City line on over 200 acres at Chesowlde's northwest corner between 1930 and 1945. William Tipton, flying ace and World War I hero, leased the airport, where he serviced planes and conducted an aviation school. During the Depression, it was Baltimore's locale for stunt fliers, daredevil parachutists, and airborne vaudeville. In 1946, it became Pimlico Airport, and by the early 1960s, the property was developed into Greenspring Shopping Center. (Courtesy of the Photograph Collection of the Baltimore County Public Library.)

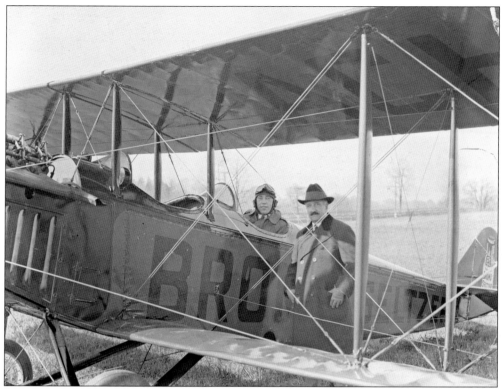

Bromo-Seltzer Plane at Curtiss-Wright Airport. An unidentified pilot sits in the cockpit and poses for this shot with an unidentified gentlemen dressed in business attire. Capt. Isaac Emerson founded the Emerson Drug Company and invented a headache remedy called Bromo-Seltzer. The Bromo-Seltzer Tower, designed by Joseph Evans Sperry, is still a familiar landmark in downtown Baltimore. Built in 1911, it was considered the tallest building in the city at that time. (Courtesy of the Baltimore Museum of Industry.)

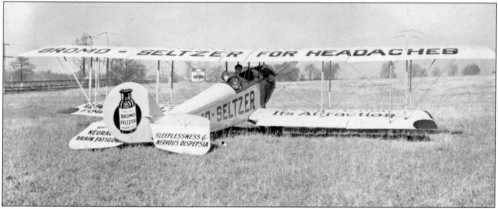

Bromo-Seltzer Plane Advertisement. This plane advertised the famous headache remedy Bromo-Seltzer produced by the Emerson Drug Company. Various medias of advertising were used during the early 1900s that included poster advertisements as well as plane advertisements. Maj. Alexander de Seversky, famed plane designer and holder of world flying records, appeared in some of the advertisements with the saying, "When a headache slows me down, makes me jumpy, I take Bromo-Seltzer." (Courtesy of the Baltimore Museum of Industry.)

TRAIN AGENT, C. 1890. This is a portrait of Conrad Kirschner, the train agent at the Mount Washington station of the Northern Central Railway between 1881 and 1907. The suburban station at Mount Washington was a two-story board-and-batten design typical of the 1870s that provided living space for the agent and his family. (Courtesy of the Photograph Collection of the Baltimore County Public Library.)

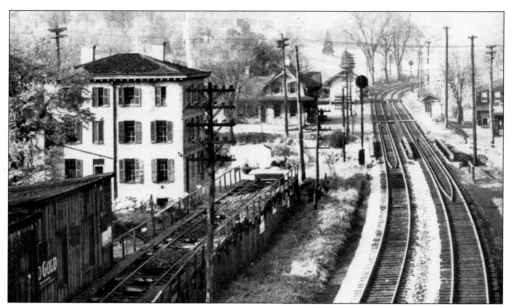

LATE-1890S MOUNT WASHINGTON HOUSE. In 1854, George Gelbach designed this structure to serve as a store, post office, train station, and hotel. The Northern Central Railway tracks ran past the Mount Washington House and the train agent's house on the left. Local resident Weidey kept a general store at the Mount Washington House from the early 1870s to the turn of the century. The building was used by various businesses until its demise in the early 1950s. (Courtesy of the Photograph Collection of the Baltimore County Public Library.)

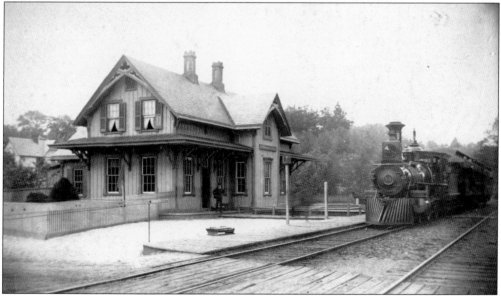

NORTHERN CENTRAL RAILROAD STATION. The Northern Central Railroad had become world famous for its immaculately maintained main line, the beauty of the landscape along its route, and its distinctively designed trackside structures. Attention was given to creating unique buildings that would give distinct personalities to both the railroad and its communities. Many train stations were the work of commercial architects rather than railroad draftsmen. (Courtesy of the Photograph Collection of the Baltimore County Public Library.)

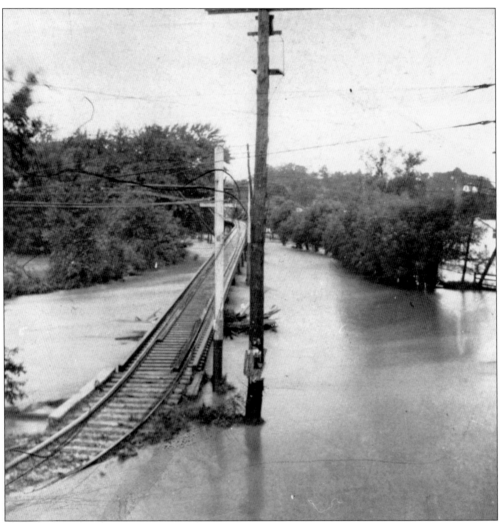

FLOODED TRACKS, 1905. Henry Parr and George Webb of the Electric Light and Railway acquired clearance from the Northern Central Railroad to construct a viaduct over its tracks at Mount Washington so that service could be extended to Kelly Avenue and Arlington. Erected by the Phoenix Bridge Company, the original viaduct was designed to carry a single track. The first car made its maiden run over the trestle to Falls Road on October 17, 1897. In 1907, an additional track was added to provide a more efficient traffic flow. A system of flags by day and lanterns by night warned approaching traffic until electric lights were installed. Due to the confluence of Western Run and the Jones Falls, waters can rise swiftly and cause major flooding in the Mount Washington area. Heavy rains swelled the Jones Falls over the eastern end of the track, delaying traffic for days. Later improvements to the dam at Lake Roland and work by the city, state, and federal agencies have tried to insure that floods of this magnitude are a thing of the past. (Courtesy of the Photograph Collection of the Baltimore County Public Library.)

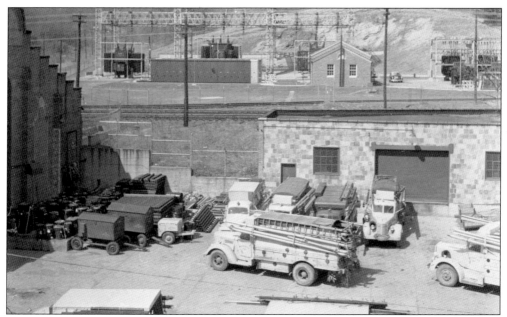

MOUNT WASHINGTON LIGHT AND POWER COMPANY. This company was once located on the north bank of the Jones Falls. In the July 2, 1904, issue of the *Electrical Review*, the following excerpt was noted: "The county commissioners have closed a contract with the Mount Washington Electric, Light, and Power Company for furnishing electric lights for public highways at Mount Washington and for some outlying areas." (Courtesy of the Mount Washington School.)

STATION AT WESTERN RUN, C. 1910. Traveling by trolley or streetcar was the main means of public transportation throughout the neighborhood before the automobile appeared on the road. The station pictured here at Western Run served as more than a depot. According to Mark Miller's book on Mount Washington, as early as 1901 "one could purchase cigars, cigarettes, tobacco and candy to please the most fastidious." The view of Western Run is indicative of a dry spell. When the streetcar disappeared, this was Crawmer's Store, a favorite stopping place in the neighborhood, especially for children after school. (Courtesy of Mark Miller.)

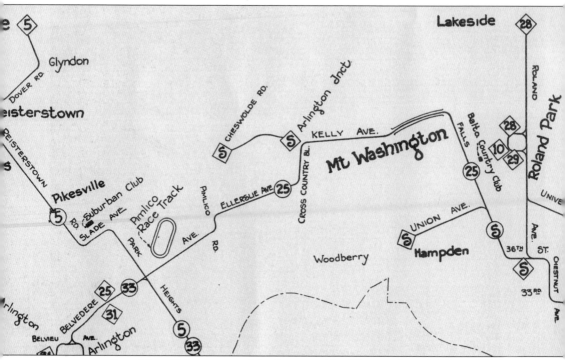

STREETCAR LINE MAP. This is a map of the Streetcar No. 25 route through Mount Washington. Before the automobile, people depended on streetcars to get to school, go downtown to movies and the Hippodrome Theater, go shopping, attend dance classes, or go to the Peabody and the Pratt Library. Streetcar No. 25 ran along Ken Oak Road and then onto Falls Road, linking Mount Washington to downtown areas. (Courtesy of the Baltimore Streetcar Museum.)

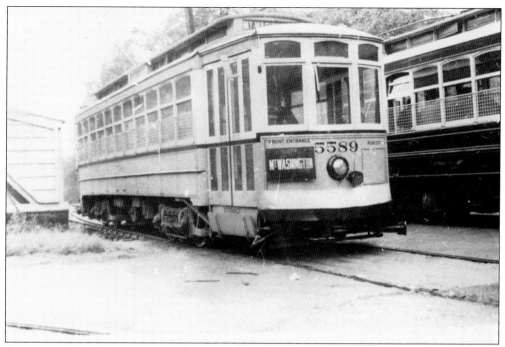

STREETCAR NO. 5589 ON THE 25 LINE. Emily Miller Rody recalled the following about riding the streetcar in 1939: "The Number 25 was a floating opera. Claire Rosenbush, Natalie Bisgyer, Allene Roos, Joan Strouse, we would board at Cross Country to go either to Garrison Junior High School, or in my case, downtown to the Peabody where I took piano lessons. I traveled by myself, at age ten or eleven. When we went by the Pimlico track and the horses were running, the motorman would stop the car and let us watch. My dates often took me downtown on the streetcar." (Courtesy of the Baltimore Streetcar Museum.)

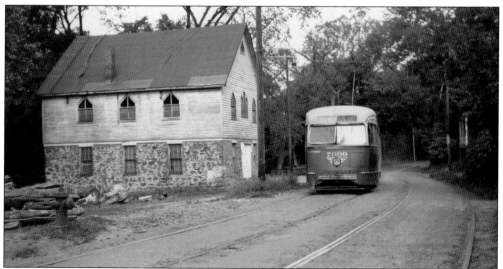

STREETCAR NO. 7009. Prior to the construction of the Kelly Avenue viaduct, the streetcar traveled via Falls Road to Kelly Avenue and through the Mount Washington neighborhood. Here, the route travels on Kelly Avenue past the Methodist Episcopal church, now known as Mount Washington-Aldersgate United Methodist Church. (Courtesy of the Baltimore Streetcar Museum.)

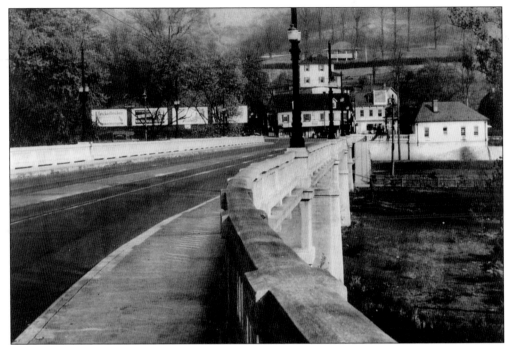

KELLY AVENUE VIADUCT. By 1925, the decision was made to build a new viaduct over the Jones Falls and the railroad tracks to accommodate streetcars and automobiles and to alleviate the Smith Avenue bottleneck. The 800-foot span was completed in October 1926 at a total cost of $322,620 and opened for traffic on July 11, 1927. Roche's Store is seen in the background on the east side of Falls Road at the entrance to the bridge. (Courtesy of Mark Miller.)

TRAVELING BY STREETCAR. A streetcar is on its way through the outlying area of Mount Washington to the Belvedere Loop. The car linked Mount Washington and other areas to downtown by traveling up Falls Road to Kelly Avenue, past the Pimlico Racetrack, across Park Heights Avenue to the Belvedere Loop, and then making its return. (Courtesy of the Baltimore Streetcar Museum.)

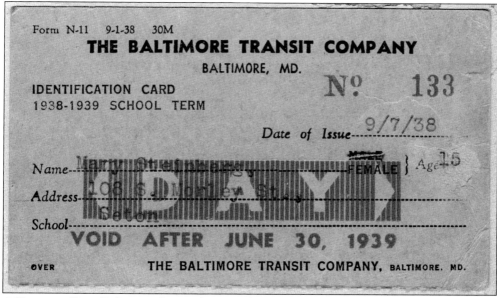

Form N-11 8-17-36 35M

THE BALTIMORE TRANSIT COMPANY
BALTIMORE, MD.

IDENTIFICATION CARD
1936-1937 SCHOOL TERM

BTC

N⁰ 16243

Date of Issue----9/14/36----

Name----Mary Steinberg----FEMALE } Age-15-

Address----108 S. Morley St.,----

D.

School----Seton----

VOID AFTER JUNE 18, 1937
OVER THE BALTIMORE TRANSIT COMPANY, BALTIMORE. MD.

STUDENT PASS. This is a sample of a student pass or identification card for riding the streetcar. The student was 15-year-old Mary Steinberg; she traveled to Seton High School from her home on Morley Street from September to June. (Courtesy of the Baltimore Streetcar Museum.)

Form N-11 9-1-38 30M

THE BALTIMORE TRANSIT COMPANY
BALTIMORE, MD.

IDENTIFICATION CARD
1938-1939 SCHOOL TERM

N⁰ 133

Date of Issue----9/7/38

Name----Mary Steinberg----FEMALE } Age 15

Address----108 S. Morley St.,----

School----Seton----

VOID AFTER JUNE 30, 1939
OVER THE BALTIMORE TRANSIT COMPANY, BALTIMORE. MD.

A TICKET TO RIDE. Baltimore City students purchased streetcar passes from the Baltimore Transit Company at a reduced rate each school season. The design of the pass usually changed each school year. (Courtesy of the Baltimore Streetcar Museum.)

NEWBURY STREET, 1954. This is a view of the Newbury Street business district in Mount Washington Village. Imhoff and Fleishman Grocery Store was located on the left side, hidden by the tree line. The building on the right was Smith and Hamilton Grocery Store, which later became Sparwasser's Tavern, and today, it is the Mount Washington Tavern, a favorite gathering place in the neighborhood. In the background, one can see the roof and turret of the old Casino. (Courtesy of Mark Miller.)

Looking east along car line from Pimlico Road.

STREETCAR LINE ON LINWOOD AVENUE, 1908. This postcard view is looking east from Pimlico Road down Linwood Avenue (today known as Ken Oak Avenue.) This photograph appeared in a brochure from the Manhattan Land Company, an advertising piece used to inform the public that Mount Washington Heights was accessible by trolley and by auto. After the Baltimore Transit Company discontinued electric car service in the late 1940s, the city covered the tracks with a grass median. (Courtesy of Mark Miller.)

INTERSECTION OF KELLY AND SULGRAVE AVENUES AND GREELEY ROAD. In 1897, George Webb, president of the Electric Light and Railway, extended rail service from Falls Road through Mount Washington. He laid tracks over an old trail running westward on a parallel course with a stream (now Western Run). This trail became Kelly Avenue, named after Simon Kelly, a signal operator who was charged with the responsibility of insuring a safe traffic flow at the Smith Avenue-Northern Central grade crossing. (Courtesy of Mark Miller.)

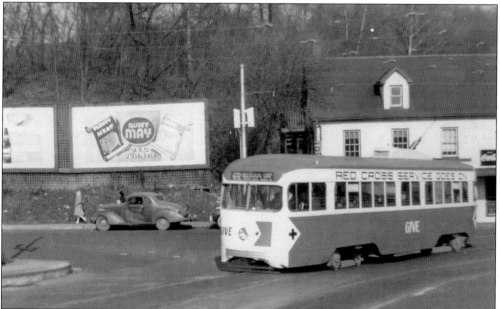

STREETCAR AT KELLY AVENUE BRIDGE. The Kelly Avenue Bridge opened in 1912, and street widening along Sulgrave Avenue and South Road claimed land, houses, and other structures. Nearly half of the old African American section was leveled. The streetscape further changed when streetcars were removed. Kelly Avenue was widened between Greeley Avenue and Cross Country Boulevard in the late 1940s to allow for bus traffic. (Courtesy of the Baltimore Streetcar Museum.)

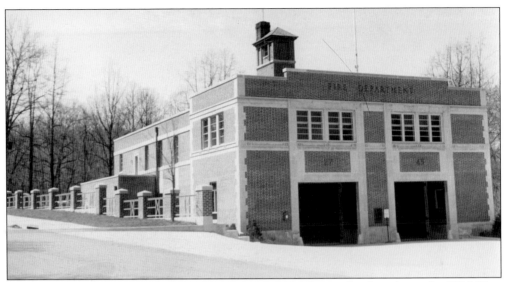

GLEN AVENUE FIRE STATION. The Mount Washington Fire Station has been located at 2700 Glen Avenue since 1951. The paid firefighters of Engine Company No. 45 service the western side of Mount Washington, while Engine Company No. 44 services the eastern side. For over 50 years, firefighters, their families, and neighborhood volunteers have erected an annual train garden at the firehouse. The garden is on view during the month of December. There is no admission charge, but donations are welcome. (Courtesy of the Mount Washington School.)

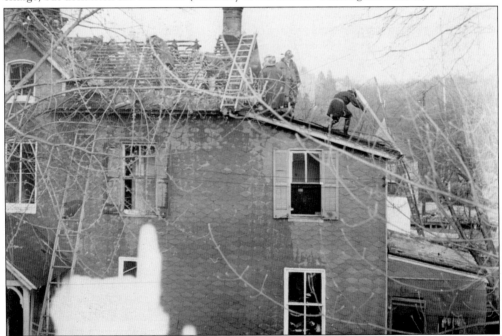

LOCAL HOUSE FIRE. Local firefighters responded to a house fire on Sulgrave Avenue. The Sawerwein family donated a portion of their estate as a site for a firehouse in the village, which was completed in May 1892. When Mount Washington was annexed to the city in 1919, the community fire engine became No. 45 and was transferred to the Glen Avenue house in 1951. (Courtesy of the Mount Washington School.)

ENGINE COMPANY NO. 21.
Firemen from this unit located on Union and Roland Avenues responded to a fire at Kelly and Sulgrave Avenues in Mount Washington. By the early 1950s, most fires in Mount Washington came under the domain of Engine Company No. 45 on Glen Avenue. The second St. John's Church is shown in background, and to the left (but not shown) is the Casino before its demolition in 1958. (Courtesy of the Mount Washington School.)

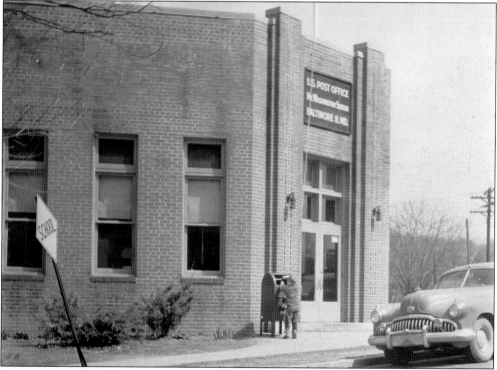

MOUNT WASHINGTON POST OFFICE. Prior to 1854, mill workers from Washingtonville picked up their mail at the Hollins Railroad Station. Later that same year, due to the development of Mount Washington, the postal headquarters moved to Weidey's Store by the railroad tracks. The post office bounced around to various locations over the next 75 years until coming to rest at this location on the corner of Kelly and Sulgrave Avenues. It remained there until 1970, when it moved to its present location on Cottonworth Avenue. (Courtesy of the Mount Washington School.)

WALTER SCHWAB, STORE OWNER. Walter Schwab owned the grocery store, the Mount Washington Popular Grocery, "the Always Busy Store," at 39 Mattfeldt Avenue in the Sabina-Mattfeldt neighborhood off Falls Road in the early 1900s. The neighborhood takes its name from the original landowner Charles Mattfeldt, who constructed houses there between 1886 and mid-1890s. A streetcar line connected this area to downtown via Falls Road and made the area very desirable for home construction. Receipt books from the grocery store in 1924 listed the following grocery items sold, which were all under $1: sugar, 17¢; butter, 23¢; crackers, 6¢; potatoes, 10¢; bread, 18¢; and soap, 7¢. Coffee was one of the more expensive items at 54¢. And a pork roast cost 98¢. (No quantities or sizes were mentioned.) Scwab's store was not the only store in town. Other grocery stores in the neighborhood included Smith and Hamilton and Roche & Son in the village of Mount Washington. (Courtesy of Chris Shafer.)

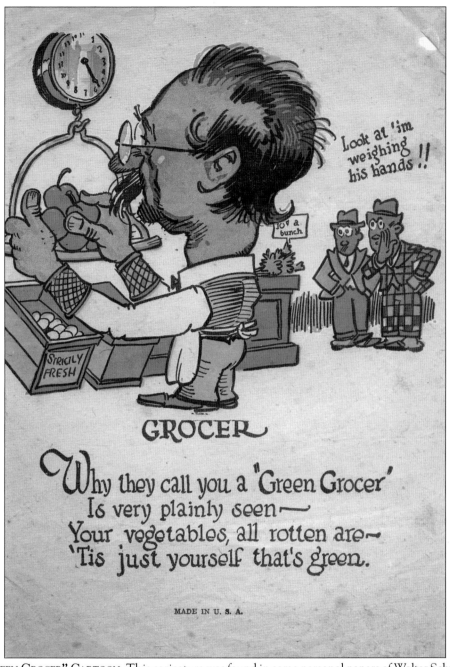

"Green Grocer" Cartoon. This caricature was found in some personal papers of Walter Schwab, owner of the Mount Washington Popular Grocery. Note the caption off to the right—"Look at 'im weighing his hands!!" According to a *Baltimore American* newspaper article dated June 25, 1926, Schwab and his daughter had fallen prey to a blackmail scheme by Michael Huber, a presumed medical doctor and German spy. In a letter signed KKK, Huber demanded that $1,500 be placed in a package and left in a garage on Frederick Road. Detectives planted a bogus package and arrested Huber on the spot. Huber claimed that he had "lost his nerve." No further details were revealed in the article. (Courtesy of Chris Shafer.)

MOUNT WASHINGTON BUSINESS ADVERTISEMENTS, 1894. These are advertisements placed by Mount Washington businesses that appeared on the back page of the August 1894 issue of *Mount Washington Advocate*. The advertisements represent a variety of businesses in Mount Washington at the turn of the 19th century, such as Smith & Hamilton, dealers in staple and fancy groceries, hay, grain, coal, lumber, lime, and builder's hardware, and S.J. Roche, a dealer in flour, grain, lime, hay, and straw. (Courtesy of the Photograph Collection of the Baltimore County Public Library.)

DR. JOSIAH S. BOWEN JR. Like his father, the younger Dr. Bowen entered the medical profession and lived at 1710 South Road. He razed the family home at this location and built a new residence there in 1908. He became the Baltimore County health commissioner. His hobby was researching and collecting historical materials to compile a history of Mount Washington. However, due to a heart ailment, he died in 1944 before completing the manuscript. His father, Dr. Josiah Bowen Sr., came to Mount Washington in 1865. He served the community as a general practitioner for 35 years and is said to have officiated at the birth of approximately 1,300 babies. He was a visiting physician at Mount St. Agnes and a surgeon for personnel with the Northern Central Railroad. As a member of the Board of Road Supervisors, he was instrumental in opening up Rogers Avenue and South Bend Road. Dr. Bowen Sr. died sitting in his office chair at home in August 1900. (Courtesy of the Photograph Collection of the Baltimore County Public Library.)

Two

HISTORIC HOUSES

In June 1854, George Gelbach, real estate developer, turned his vision into reality when he developed this area into a summer retreat he named Mount Washington Rural Retreat. The idea of commuting between home and job to destinations beyond walking distance was a unique concept. The site he chose lay in the path of the Baltimore & Susquehanna Railroad's northern line, later to become Northern Central Railroad. The railroad played an important role in the development of his retreat, offering transportation for businessmen to travel to their offices in the city and back again to their home in the evening. Other developers such as John Graham, John Nichols, Thomas and James Dixon, George Whitelock, Thomas Kennedy, and the Cottage Building Association followed suit with developing some of the outlying areas of Mount Washington. The Manhattan Land Company, managed by C. Brosius Reed, purchased the Frank Knell estate and developed the Mount Washington Heights area north of the village.

Mount Washington is a blend of houses constructed in the styles of Second Empire, American Gothic, Victorian Gothic, Queen Anne, and Stick-style architecture. Orson Squire Fowler inspired the construction of octagonal structures for the greater heat, light, and ventilation. A variety of Victorian features such as gabled roofs, dormer windows, widow walks, mansard roofs, and turrets (or battlements) adorn these spacious homes of the late 19th century. The Swiss chalet homes along Roxbury reflect a regard for exposed wooden materials with exterior framing and high steep roofs. And Shotgun-style homes were prevalent in the African American community along Kelly Avenue. By 1875, the community lost its exclusively seasonal crowd and gained people interested in year-round residency. Mount Washington has evolved into one of Baltimore County's most prestigious residential areas and is part of the Baltimore City Historic District.

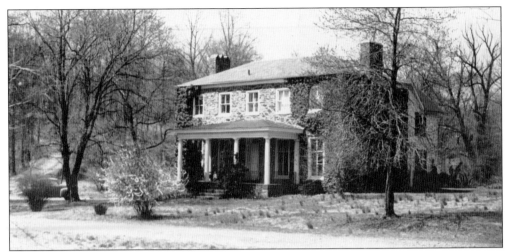

CARROLL HUNTING LODGE, 1790. One of the oldest houses in the area was built on a tract of land owned by Charles Carroll of Carrollton, a wealthy landowner and signer of the Declaration of Independence. Located at the corner of Greenspring Avenue and Pimlico Road, the property was once part of a light-industrial complex of snuff/tobacco mills along Western Run. The flood of 1868 caused severe damage to the mill, but this house survived. A marker at the site displays a lithograph by A. Hoen and Company advertising the Pimlico Tobacco Works and that "ladies as well as men are shown enjoying the pleasures of tobacco." (Courtesy of the Mount Washington School.)

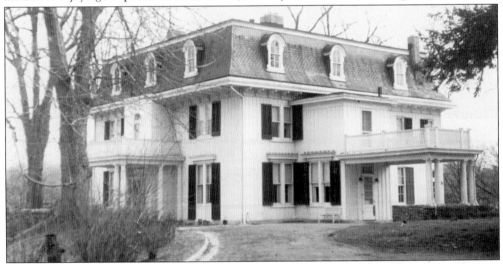

LABORIERE, 1705 SOUTH ROAD. George Gelbach, the man with the vision of Mount Washington as a summer retreat, designed and built this home on 13 acres in 1856. He and his wife, Christiana, were fond of Second Empire styling, and the mansard roof, dormer windows, and French doors leading to the veranda are reflective of that style. At one time, the house was equipped with a four-story water tower with water supplied by a nearby stream. After the Civil War, Gelbach rented the property to several different families before selling it to William Fisher, who founded William Fisher and Sons, a Baltimore lending institution. Fisher named the estate Laboriere after his third wife's middle name. During Fisher's ownership, the home served as a hall for neighborhood and church meetings, theatrical productions, and other social activities. It is interesting to note that this grand mansion was featured in the 1993 movie *Guarding Tess*, starring Shirley MacLaine and Nicholas Cage. (Courtesy of the Mount Washington School.)

NEW OAKS, 1813 SOUTH ROAD. This house was formerly called Hillside. John Graham came to Mount Washington after the Civil War and built Hillside at 1813 South Road. Later, it became known as New Oaks and served as a very reputable boardinghouse. In the August 1894 issue of *Mount Washington Advocate* newsletter, it was noted, "Mrs. Julia Shaeffer who has this summer refurnished and opened Hillside has a delightful family so far, who speak of her house in terms of grateful praise." (Courtesy of the Mount Washington School.)

THE CEDARS OR WIMBLEDON, 1912 SOUTH ROAD. Rev. Elias Heiner of the German Reformed Church built the first house on this site and named it the Cedars. He resided there for eight years and then sold the property to William Purnell, an agent of the United States Postal Service who named it Wimbledon. After Purnell moved, he deeded the lot to the Cottage Building Association of Mount Washington. Harry O. Norris acquired the property in 1913 after moving from the Rugby Institute where he had resided since 1899. Two of Norris's sons, Paul and Oster "Kid," became All-American lacrosse players. Either due to extensive renovation or perhaps complete razing, the present house retains none of its original characteristics. (Courtesy of the Mount Washington School.)

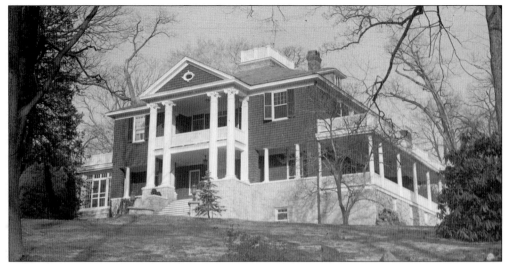

BEAUSEANT, 2100 SOUTH ROAD. Rev. James Purcell purchased this property in 1876; however, after a storm claimed his first house in 1877 and a fire the second one in 1894, he sold the property to Gen. Thomas J. Shryock, who built the present mansion, Beauseant (the banner borne by the Knights Templar in the 13th century). His daughter Amelia was married to James McDonnell Price at the elaborately decorated Beauseant on June 20, 1902, with 500 guests in attendance, and "the presents were costly and numerous." Shryock served in the National Guard, ran a lumber business, and established a career in politics. He was also grand master of the Grand Lodge of Masons of Maryland. He was appointed vice president of the State Insane Asylum and Maryland House of Governors and was the first Republican state treasurer ever elected in Maryland. (Author's collection.)

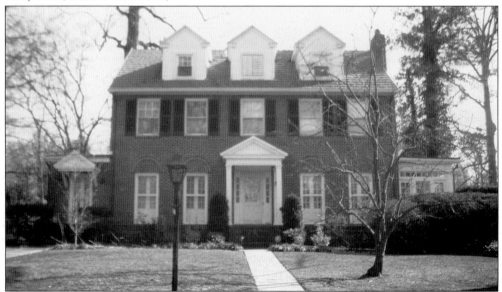

DR. TODD'S HOUSE, 2217 SOUTH ROAD. Dr. William J. Todd moved to this three-story brick Colonial in 1926 when his first residence on South Road was leveled to make way for the concrete viaduct. In July 1901, Dr. Todd read his "Medical Fathers of Mount Washington," a 5,000-word manuscript highlighting the lives of 10 local physicians, to the Baltimore County Medical Association. (Author's collection.)

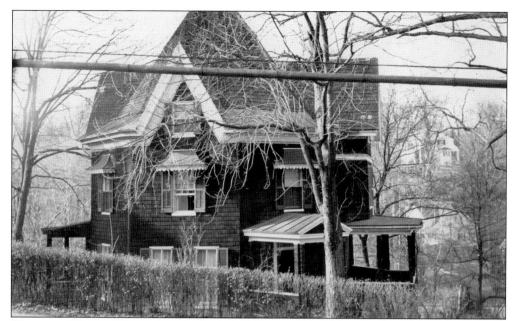

HAMILTON-WALKER HOUSE, 1808 SULGRAVE AVENUE. William Yardley, a railroad engineer for the Northern Central Railroad, obtained the deed for the lot in 1873 but did not complete the octagon house until 1880. Yardley had eight children, three of them girls. Each daughter desired a front room, and the octagonal shape permitted each daughter to have just that. (Courtesy of the Mount Washington School.)

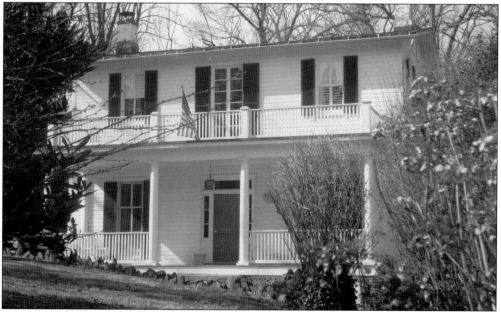

BEADENKOPF HOUSE, 1918 SULGRAVE AVENUE. Built between 1865 and 1870, this house was originally a summer residence before the Beadenkopfs purchased the property. The Beadenkopf family owned this house between 1898 and 1945. There is mention in a news article that a local artist, Anne Beadenkopf, also active in social work, donated an oil painting to Happy Hills Convalescent Home. The painting was placed in the playroom at the home. (Author's collection.)

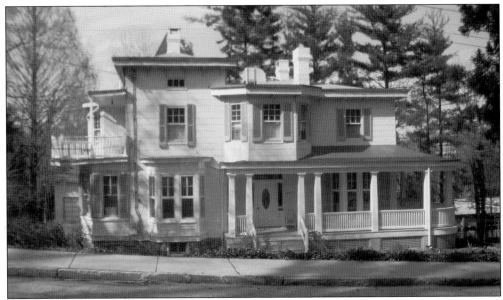

RUGBY INSTITUTE, 1806 SOUTH ROAD. Edward Arnold's Rugby Institute was one of two institutions established in Mount Washington prior to the Civil War. Arnold, a teacher who left Washington, DC, in 1848 to begin a school in Elkton, had his own ideas of what an educated man should know and believed in a varied curriculum of arithmetic, bookkeeping, history, geography, Latin, Greek, French, and philosophy. Tuition ran $112.50 per session, which included two five-month sessions. The school closed during the Civil War. (Author's collection.)

CAPT. ROBERT BARNES HOUSE, 1812 SOUTH ROAD. This house was built in 1877 by Capt. Robert Barnes and was later owned by United States-Belgian ambassador Theodore Marburg. Marburg's reputation as a diplomat, publicist, civic leader, and peace advocate led to his service as ambassador from 1912 to 1914. Records indicate that Marburg and Pres. Woodrow Wilson drafted one of the covenants to the League of Nations. (Author's collection.)

ROXBURY PLACE HOUSES. The Cottage Building Association of Mount Washington was a corporation formed by John Nichols of the Knickerbocker Life Insurance Company and John Graham. The economic recession of the late 1850s, along with the Civil War period of four years, had slowed development in the Mount Washington area for about 10 years. Their partnership gave birth to the Swiss chalet–style houses, with exposed framing, high steep roofs, and gingerbread trim, at Roxbury Place. (Author's collection.)

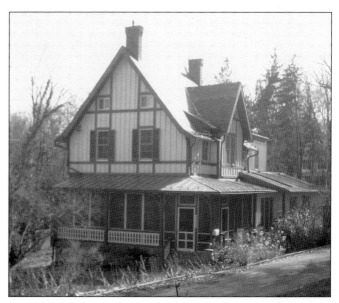

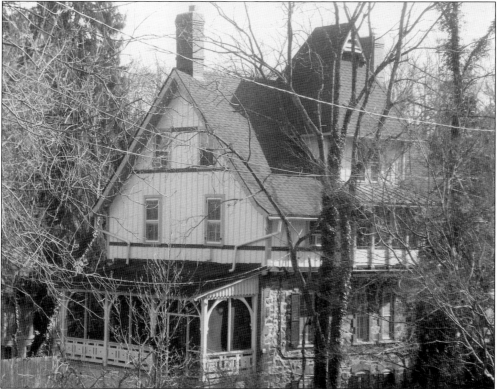

ROXBURY PLACE. Roxbury Place is a narrow winding lane that dips off near the 1800 block of South Road then into Wildwood Lane. The architecture of the homes at Roxbury Place reflects the ideas of Andrew Jackson Downing in his book *Cottage Residences*, published in 1842. Downing was an American landscape designer, horticulturalist, and writer advocate of the Gothic Revival style. He was the one person who "could be sent to look at fields and woods and tell what could be made of them," said his friend Nathaniel Willis. (Author's collection.)

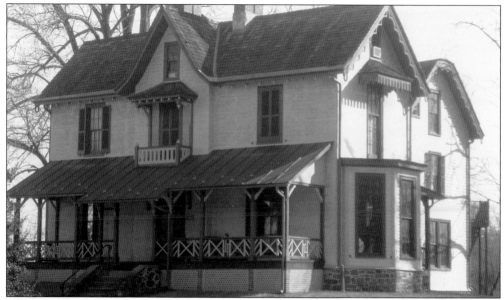

1813 THORNBURY ROAD. Built by the brothers Thomas and James Dixon, one of them resided in this house. The Dixons arrived in Baltimore in the late 1840s and began practicing architecture about 1850. They are credited with developing the Dixon Hill area of Mount Washington. James passed away in 1863, but Thomas Dixon continued to practice. He in known in the community for his design of the Mount Washington Presbyterian Church. (Author's collection.)

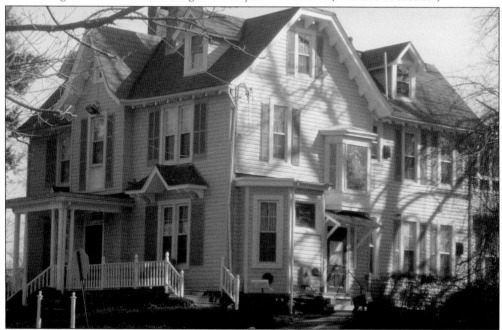

1815 THORNBURY ROAD. The Dixons built this house, and one of them resided here until W. Murray Stirling bought the property in 1878. He was the son of the president of the Baltimore Savings Bank. Stirling raised roses in a hothouse on the property and sent them by train to wholesalers in downtown Baltimore. His daughter Rosalie Graham recalled that florists would ask especially for "Mr. Stirling's roses." (Author's collection.)

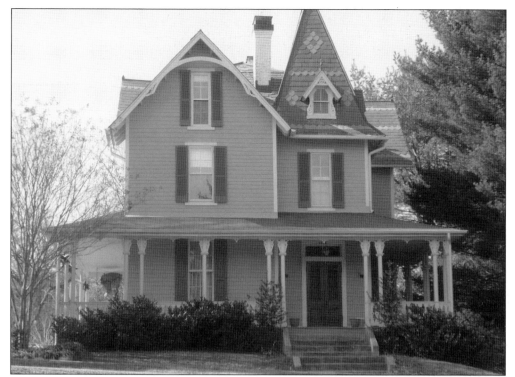

1808 THORNBURY ROAD. This house is another fine example of the Thomas Dixon brothers' style of architecture. The tract of land once called Clover Hill Farm is known today as Dixon Hill. Thomas Dixon, an architect by profession, purchased the land. In 1873, after starting a lumber company, he undertook active building operations. Within the decade, he planned and constructed 15 houses, all of which remain today. (Author's collection.)

5701 RIDGEDALE ROAD. This was once the residence of Harry Nice, governor of Maryland. The house was built in 1915, and he lived here from 1921 until his death 20 years later. The old orchard baseball field was located here. (Author's collection.)

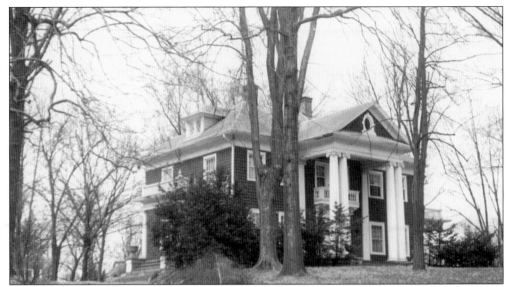

RAY WATSON HOUSE, THE TERRACES. The Dixon brothers and the architecture they admired stayed south of Smith Avenue. The Terraces lay on the north side and remained widely undeveloped until 1897. Brewery owner August Bauernschmidt and Harvard law graduate Omar Hershey acquired deeds to the tract and formed the Mount Washington Realty Company. Thomas Kennedy, a prominent Baltimore architect, designed the early homes of the Terraces. (Courtesy of the Mount Washington School.)

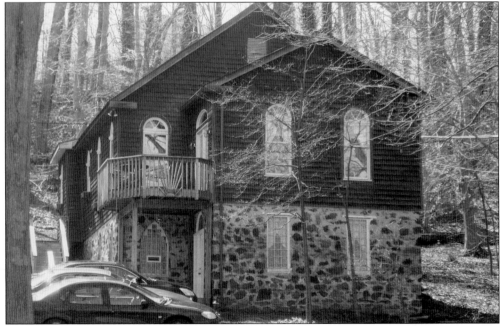

AFRICAN AMERICAN CHURCH, 2021 KELLY AVENUE. Constructed in 1912, this building served as the original St. Andrews United Methodist Church. When services were discontinued at this location, the church merged with Elderslie United Methodist Church on Pimlico Road and became known as Elderslie-St. Andrews United Methodist Church. In the late 1960s, local residents used this building as a recreation center. It became a private residence in 1979. (Author's collection.)

Three

RELIGIOUS INSTITUTIONS

Catholic, Methodist, Episcopalian, or Presbyterian? When selecting a place of worship in Mount Washington, one might have a tendency to agree with Sojourner Truth's keen observation when she visited the area. In her letter dated August 31, 1877, which appeared in the *Maryland Journal* on September 8 of that year, she stated the following:

> There are here also churches of all kinds and varieties. You pays your money and you takes your choice between Episcopalian, Catholic, Methodist, and Presbyterian. She continued to write, "Another peculiarity here is the propensity to stick the churches and public places down in the hollow near the Station, whilst the choice sites have been taken for residences, looks very much like giving the Lord the refuse and keeping the best for self.

While George Gelbach focused on building houses, Elias Hiener, minister of the German Reformed Church, envisioned Mount Washington as the ideal place to start a religious community for his church. In 1855, he built his church and the Mount Washington Female College on Smith Avenue. The church disbanded in 1861, and during the Civil War, the church became locally known as Union Chapel and was shared by several denominations. In 1867, the Sisters of Mercy purchased the property and established a novitiate and an academy there until 1971. They deeded the church, which they named St. Agnes Chapel, to the archbishop. It was soon after organized into a new parish carved from the area served by St. Mary's, Govans, and named Sacred Heart of Jesus. Masses were held in the old German Reformed Church until a new building was constructed across the road in 1917. The parish was renamed the Shrine of the Sacred Heart.

Other denominations set up church in the community in the late 1800s. In 1878, the Dixon brothers from Wilmington, Delaware, built the Mount Washington Presbyterian Church on Thornbury Road. The cornerstone of St. John's Episcopal was laid in 1869 at the corner of Kelly and Sulgrave Avenues, and Mount Washington Methodist, near the mill, was built in 1860. The African American community, after worshipping for more than a quarter of a century in a small building constructed from the sides of cable cars, laid the cornerstone of their new church, First Colored Baptist Church, on July 1, 1916.

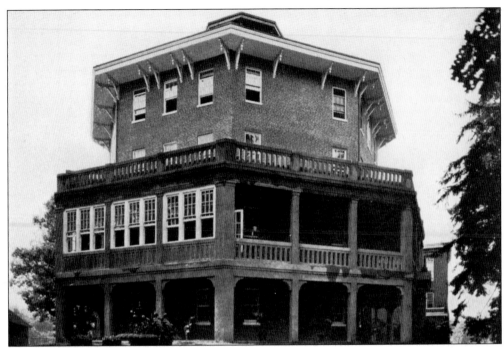

OCTAGON BUILDING, C. 1900. Orson Squire Fowler designed this five-storied octagonal structure where the German Reformed Church opened a church and a college, the Mount Washington Female College, on Smith Avenue in 1856. The property was sold in 1867 to the Sisters of Mercy, who established a novitiate and an academy that expanded to a college, Mount St. Agnes, in 1898. The college closed in 1971, and the property was sold to USF&G. In 1999, it was sold to the St. Paul Company. They, in turn, sold it to the current occupant, Johns Hopkins University. (Courtesy of the Photograph Collection of the Baltimore Public Library.)

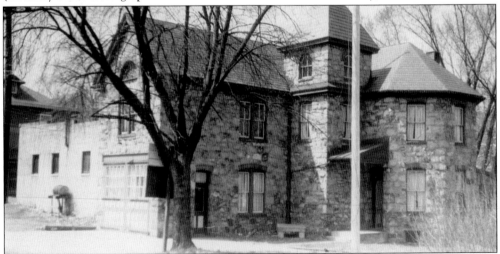

MOUNT ST. AGNES CONVENT. This building was the convent for the Sisters of Mercy in Mount Washington. In 1999, the St. Paul Company, subsequent owners of the property, donated the former convent to Baltimore Clayworks located across the street. The Gallery Building, as it is now known, opened to the public in September 2000 on the occasion of Baltimore Clayworks' 20th anniversary. (Courtesy of the Mount Washington School.)

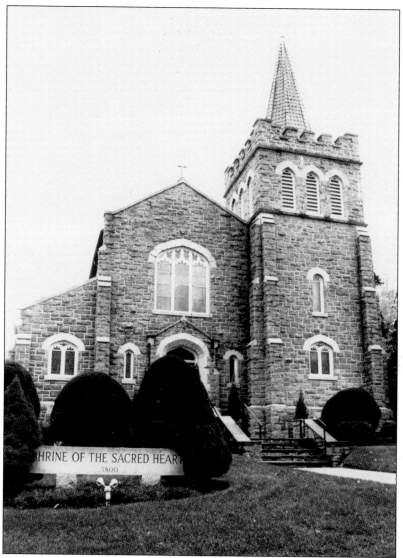

THE SHRINE OF THE SACRED HEART CHURCH. Some records indicate that the architectural style of the church is early English and that it was designed after St. Giles Church in Stoke-Poges in Buckinghamshire, Northumberland County, England, where the poet Thomas Grey wrote his "Elegy in a Country Churchyard." However, there are few similarities, and no record was ever found that Ephraim Francis Baldwin, of Baldwin and Pennington, architects, used it as an example in his design plans for the English Tudor Gothic-style church built of Port Deposit granite. On June 24, 1917, the new church opened on the old Boyden property with a solemn High Mass and Cardinal Gibbons presiding with approximately 1,500 people in attendance. The mansion on the property had been converted to a rectory. On June 25, 1925, the church was consecrated. The ceremony took place at 4:00 a.m. with a candlelight procession performed by Bishop Thomas Shahan. The cost of the building was approximately $140,000, and within eight years, the debt was cleared. (Note: This church was the last project of Baldwin's. In 1916, while working on a design for his own church, Baldwin suffered a fall and died at age 78. The Shrine of the Sacred Heart Church was built posthumously, and there is a statue of St. Anthony in front of the church dedicated in his memory.) (Courtesy of the Shrine of the Sacred Heart Church.)

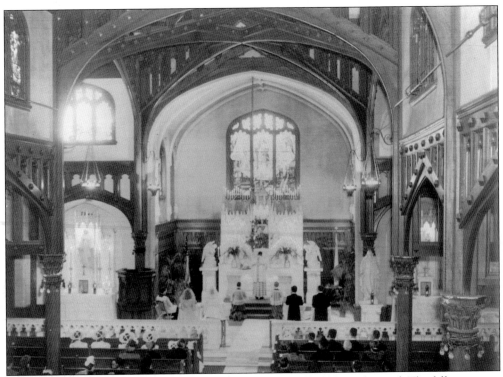

Church Interior. The interior of the church remained relatively unchanged. The following was noted in a 1914 bulletin: "The new structure will be constructed of granite and heated with steam heating and lighted by electricity." The two-story main building, made with Port Deposit granite and white oak trimmings, was 121 feet long by 50 feet wide. A chapel in the area measured 50 by 30 feet, and the main auditorium had seating for 650 people. (Courtesy of the Shrine of the Sacred Heart Church.)

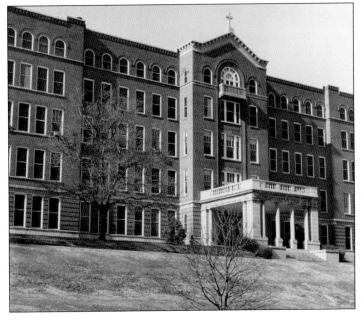

McCauley Hall. The five-story McCauley Hall was built in 1925 and was once part of the Mount St. Agnes College. By the 1950s, the majority of the college was housed in this building, until it closed in the 1970s. It included the administration offices, classrooms, labs, dining rooms, residence halls, and an auditorium. The property is now the site of the Johns Hopkins Medical Archives and Mount Washington Conference Center. (Courtesy of the Mount Washington School.)

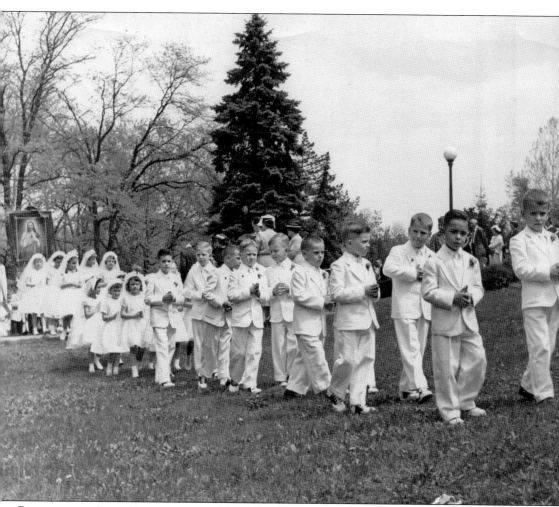

PROCESSION OF FIRST COMMUNICANTS. If raised in the Roman Catholic Church, children, usually ages seven to eight years old, take the sacrament of First Communion. This is a ritual for welcoming them into the church. The broken bread and poured wine are the true body and blood of the crucified and risen Jesus Christ. This ritual recalls the table fellowship that Jesus shared with his disciples, in particular, the Last Supper on the night before his death. All recipients of Communion must be free of grave or mortal sin, and this is granted by going to Confession, another sacrament of the recipients. (Courtesy of the Shrine of the Sacred Heart Church.)

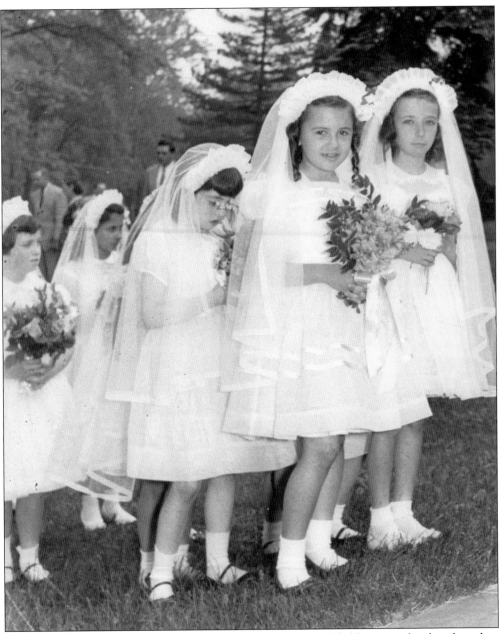

FIRST COMMUNION. This photograph captures the procession of children into the church as they prepare for their First Communion, the third of seven sacraments of the Catholicism. At First Communion, the communicants receive the Holy Eucharist (consecrated bread) and wine. The clothing for the girls is usually white, symbolizing purity. They may often wear fancy dresses and a veil attached to a wreath of flowers or hair ornament. The origin of wearing a veil most likely stemmed from the days of the Romans and early Christians when women were expected to always cover their heads. Today, some churches may require that children wear their Sunday best instead of white suits and dresses. (Courtesy of the Shrine of the Sacred Heart Church.)

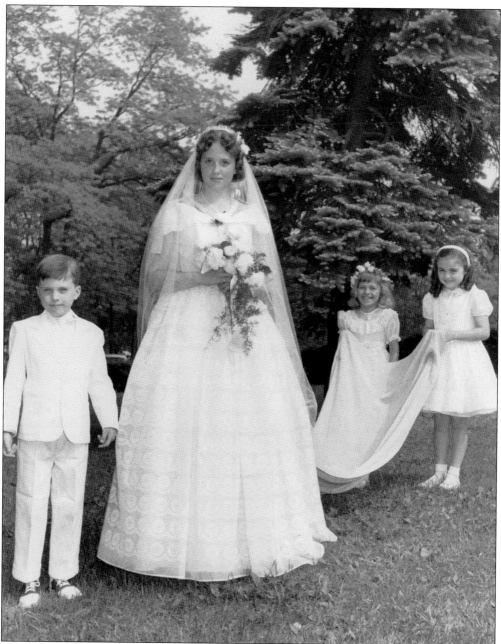

MAY QUEEN. Devotions to the Blessed Virgin Mary during the month of May have existed since the 16th century in the Roman Catholic Church. The crowning is a traditional Roman Catholic ritual believed to have originated in Italy. Young girls in white dresses carry flowers to the adorn the statute of Mary. One of the girls (usually the youngest) carries a crown with flowers or an actual golden crown for placement on the statue of Mary by the May queen (the oldest girl). In this 1957 photograph, Nancy Clark served as May queen. (Courtesy of the Shrine of the Sacred Heart Church.)

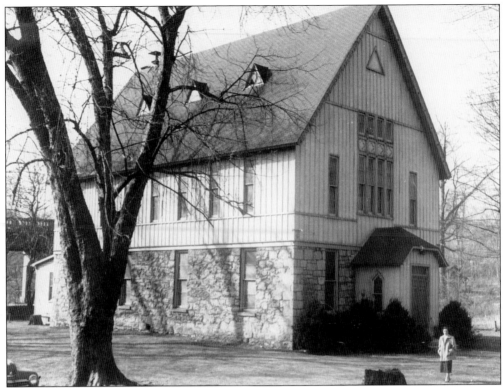

METHODIST EPISCOPAL CHURCH. In 1860, the cornerstone for the Methodist Episcopal Church was laid, and the church was built on land donated by William Hooper, a mill owner. The mill bell summoned workers to church services. After a fire in 1877, the church was rebuilt with a second-floor sanctuary added. In 2009, Mount Washington United Methodist Church (UMC) joined with Aldersgate UMC to become Mount Washington-Aldersgate UMC. (Courtesy of the Mount Washington School.)

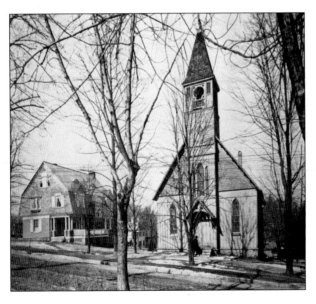

ST. JOHN'S EPISCOPAL CHURCH. In 1867, an Episcopal congregation with five families first met in the old German Reformed Church. After leaving there, they met in a grove that was later cleared for a trolley car station. The congregation then moved their services to Saffell Hall. In 1868, William Saffell conveyed part of his land to the church for the erection of a permanent structure that was built in 1869. This original church was razed in 1928 due to the widening of Kelly Avenue, and a new church was built. (Courtesy of the Photograph Collection of the Baltimore County Public Library.)

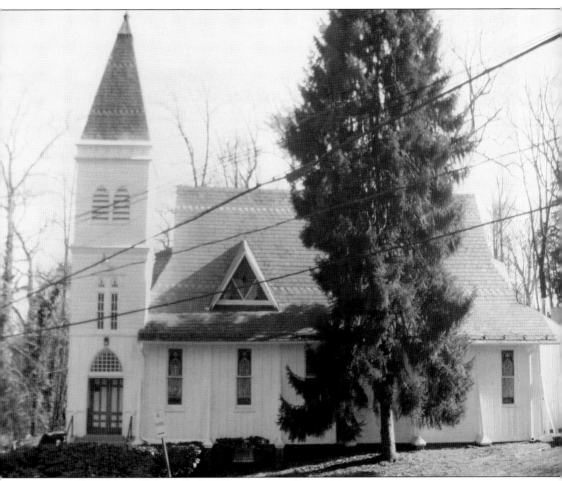

MOUNT WASHINGTON PRESBYTERIAN CHURCH. Built in 1878 by John Dixon, this church is an example of Stick-style architecture. Its exposed beams and vertical board-and-batten evoke the Gothic but not the heavy masonry of Victorian Gothic. A shed behind the church sheltered horses and buggies. The Guth family, owners of Guth Cola, had possession of the property from the 1930s to the 1960s. It has been owned by Chimes, a Baltimore-based nonprofit that provides jobs and care for the disabled, since 1968. (Courtesy of the Photograph Collection of the Baltimore County Public Library.)

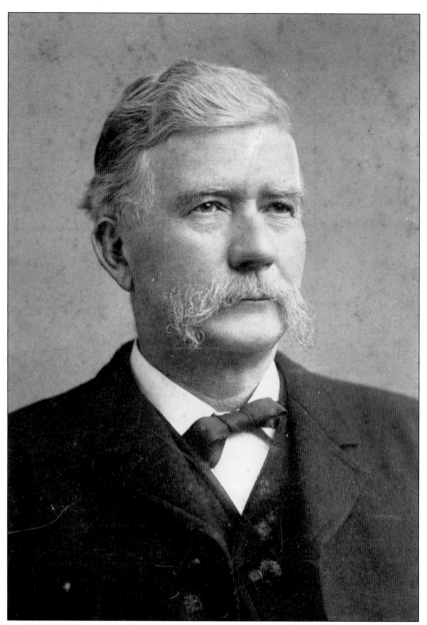

JOHN CARTER. John Carter was vestryman at St. John's Episcopal Church for more than 30 years and was founder of the original Mount Washington Improvement Association. Carter, along with John Graham, Edward Gernand, and W.S. Powell were present at its first official meeting on November 30, 1885. With their mission to improve certain conditions in the neighborhood, the following excerpt appeared in the first recorded minutes: "We are organized to secure better roads, better lighting, better drainage, better police protection and better public conveniences in our village." Membership in the association was limited to Mount Washington residents within "very defined geographic boundaries." Soon after its formation, the new association began a drive to incorporate Mount Washington. Even though the petition was first met with enthusiasm from the legislature in Annapolis, the bill did not pass. In 1919, Mount Washington was annexed into Baltimore City. (Courtesy of the Photograph Collection of the Baltimore County Public Library.)

Four

SCHOOL DAYS IN
MOUNT WASHINGTON

Home buyers were not developer George Gelbach's only clientele. The young community of Mount Washington also appealed to a group of investors interested in maintaining educational institutions there. Edwin Arnold's Rubgy Institute was one such institutions established prior to the Civil War. He had his own ideas of what an educated man should know and believed in a varied curriculum of arithmetic, bookkeeping, history, geography, Latin, Greek, French, and philosophy. Higher education for children of parents with means often meant a trip north to the city's institutions. The Mount Washington Female College opened in 1856 and offered a curriculum attractive to the daughters of Southern folks. In a four-year program, teenage girls studied classical literature, European languages, music, and social graces. Belle Boyd arrived at the school at the age of 12 from her home in Martinsburg. Later, she was under suspicion as being a Confederate spy since she had attended war councils held at her aunt's house in Martinsburg. She was captured twice but never convicted. The school closed in 1861 because Southern parents were reluctant to send their daughters to a boarding school that was in close proximity to Northern troops. In 1867, the Sisters of Mercy opened Mount St. Agnes College in the octagon building on Smith Avenue and operated it until 1971.

In Sojourner Truth's letter in the *Maryland Journal* dated September 8, 1877, she expressed the following need for a public school:

> One of the great necessities of this beautiful village is a public school. There are now over forty or fifty children in this place who lack the discipline of a school. The two small schools here are primary in their character and teachings. I know that at this moment that there are several families who hesitate about taking up residence here because of the lack of public school facilities for their children.

The first public school, Mount Washington Elementary School, was built in 1881, and other private and religious-based schools either opened or relocated to this area. In addition to Mount St. Agnes College, already in existence at this time, other schools included St. Paul's School for Boys, Mount Washington Country School for Boys, the Shrine of the Sacred Heart Catholic School, the Waldorf School of Baltimore, and Bas Yaakov School for Girls.

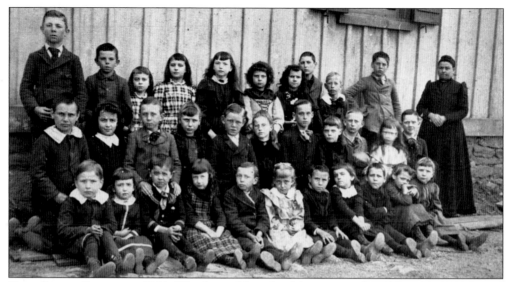

FIRST PUBLIC SCHOOL, C. 1893. The first public school, known as school No. 12, was organized in September 1863 with Charles Hall as the principal. In 1865, Sallie Welsh (third row, far right) became principal and served for 36 years. The school became known as Miss Sallie Welsh's school. She did not "spare the rod," and she "spanked many students." When the school closed in 1907, her students were transferred to Saffell Hall. (Courtesy of the Photograph Collection of the Baltimore County Library.)

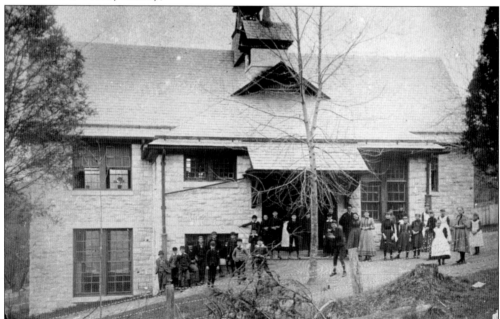

THE STUDENTS OF MOUNT WASHINGTON SCHOOL NO. 221, C. 1886. The school records indicate that the construction of School No. 8, located at North Avenue and Second Street (later named Sulgrave Avenue and Lochlea Road in 1928), was begun in 1881. In 1919, Mount Washington, then a part of Baltimore County, was annexed to Baltimore City, and School No. 8 became City School No. 221. The building was constructed of white stone adorned with a rather elaborate bell tower. (Courtesy of the Photograph Collection of the Baltimore County Library.)

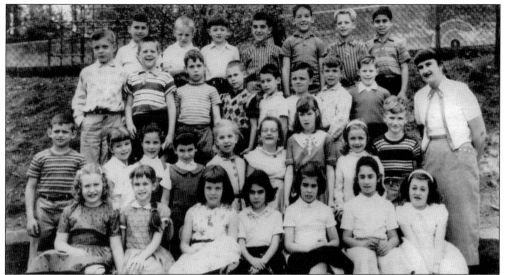

School No. 221, 1957. This is a photograph of one of the last classes at the old School No. 221 that was razed in 1961. The Department of Education of Baltimore City had purchased the Enoch Pratt Free Library Branch No. 21 for $20,000 to use it as an annex for School No. 221. Remodeling of the building for school use cost the department $9,528.97. (Courtesy of Mark Miller.)

Shrine of the Sacred Heart School. The school was founded in 1867 and was once housed on the grounds of Mount St. Agnes College and was staffed by the Sisters of Mercy. In 1872, a two-room schoolhouse served for 40 years. The new school officially opened on Monday, September 18, 1959. Father Stickney, who had been active in the preliminary planning for the new school and auditorium, passed away before its completion. Fr. Francis Linn continued to oversee the planning and construction of the school. (Courtesy of the Shrine of the Sacred Heart Church.)

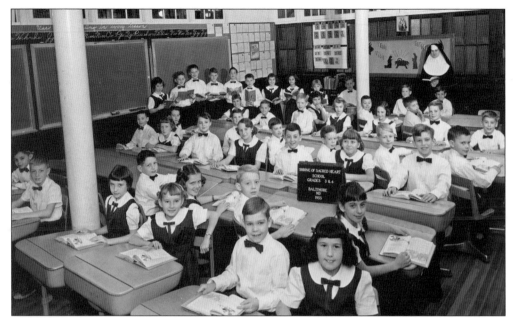

THIRD AND FOURTH GRADES AT SHRINE OF THE SACRED HEART, 1965. In 1917, the school moved to the church undercroft until the new school was built in 1959. There were four classrooms, two grades per room, with one teacher (nun) for both grades. At lunchtime, some of the children were assigned to walk up the hill to Mount St. Agnes with lunch for the Sisters of Mercy. (Courtesy of the Shrine of the Sacred Heart Church.)

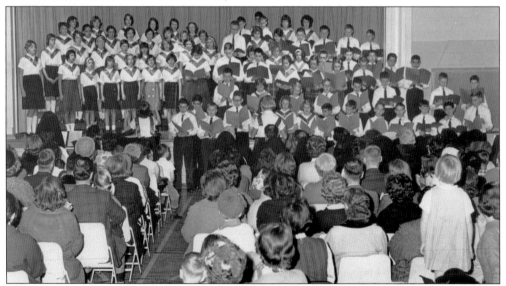

SCHOOL PROGRAM AT THE SHRINE SCHOOL. This is a photograph of a students' special program in the Shrine of the Sacred Heart School auditorium. The Shrine was one of the first Catholic schools in the archdiocese to be integrated. At one time, the school had an immigrant population with students representing 42 countries. Children came from Buddhist, Jewish, Muslim, and Christian backgrounds. Due to a decline in enrollment, the school closed in 2010. The Mount Washington School has been occupying the building for its lower grades since 2011. (Courtesy of the Shrine of the Sacred Heart Church.)

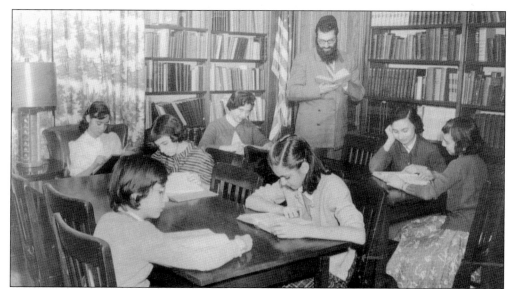

BAIS YAAKOV SCHOOL AT RUSCOMBE MANSION. The Bais Yaakov School for Girls, a Jewish-affiliated school, was established in Baltimore in 1942. In 1948, the school relocated to the Ruscombe Mansion, and classes were held there until a fire gutted the front section and attic in 1955. Later, the Waldorf School of Baltimore held classes in the mansion before opening a new school in the area. The Azola family purchased and restored the building for commercial use in 2007, and Ruscombe is listed in the National Register of Historic Places. (Courtesy of the Azola family.)

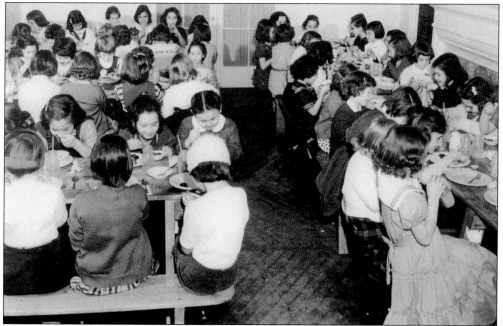

LUNCHTIME AT BAIS YAAKOV. Seamstress Sarah Schenirer started the Bais Yaakov movement in 1917 in Krakow, Poland. Schenirer's mission was "to train Jewish daughters so that they will serve the Lord and fulfill the commandments of the Torah." Bais Yaakov provides daughters of the community of Baltimore with the best *chinuch* (Jewish upbringing) possible, together with a high-quality education. (Courtesy of the Azola family.)

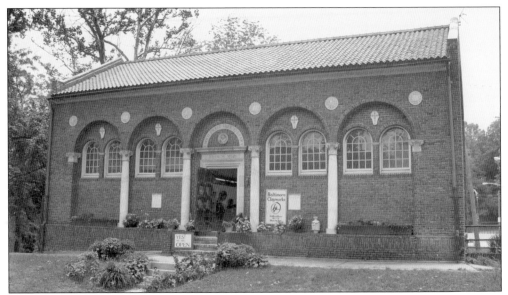

ENOCH PRATT FREE LIBRARY BRANCH (NOW BALTIMORE CLAYWORKS). The family of John M. Carter donated this land for the building of the Enoch Pratt Library Branch No. 21. Edward H. Glidden, architect, designed the building, and the branch opened on January 5, 1921. It closed in 1951. It served as a school annex prior to its current resident, Baltimore Clayworks, moving to that location. Founded in 1980, Baltimore Clayworks is nonprofit cultural organization that provides outstanding educational, artistic, and collaborative programs in the ceramic arts. (Courtesy of Baltimore Clayworks.)

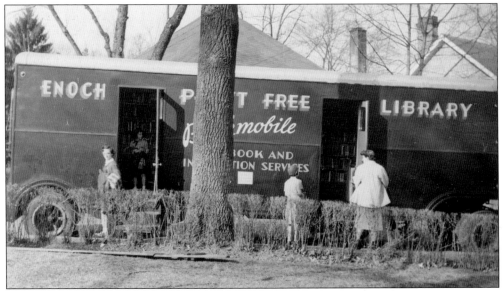

ENOCH PRATT FREE LIBRARY BOOKMOBILE. Enoch Pratt Library Branch No. 21 closed on February 17, 1951, and a bookmobile was assigned to service the area much to the dismay of area residents. The Pratt Library Annual Report in 1913 had noted a drop in summer book circulation figures in northwest Baltimore. The report stated, "People in semi-suburban sections like this live principally out of doors and on their porches in the warm weather and do not care for the exertion of reading." (Courtesy of the Mount Washington School.)

Five

Entertainment and Sports in Mount Washington

Mount Washington had much to offer its residents in the areas of entertainment and sports. The Casino was a focal point for musical entertainment in the early 1900s. This Queen Anne Victorian landmark was most eloquently described in the following June 14, 1884, issue of the *Maryland Journal*:

> The main hall was 30 feet wide and 45 feet long, with a stage 15 feet wide, provided a green-room, dressing rooms, etc. It has an open timbered roof and a gallery at the end over the entrance lobby. The first portion of the building provides a supper room 16 by 28 feet with lodge or meeting room above and a kitchen in basement. The main entrances are in front and on the side, with a coatroom for ladies and gentlemen. The building is heated by a furnace and lighted by gas. The entire interior is finished in yellow pine, left in the natural color and polished. The exterior is quite picturesque in outline and coloring, and a tower with open observatory, surmounted by a gilded vane and finial, serves to point out the structure from a distance. A large window of richly stained glass from McPhersons of Boston is placed in the front gable of the main hall. The new hall was appropriately opened with a grand ball which was largely attended and which proved a very delightful affair. A special train from the city brought out a large number of guests and Harris, the well-known caterer, had charge of the refreshments.

Its neighbor, Norris Field, was the center for sports in the area. In the late 1800s, a group of prominent men in Baltimore County and City formed the Baltimore Cricket Club to promote cricket and other outdoor sports. The Mount Washington Men's Lacrosse Club was founded in 1904 with the assistance of Johns Hopkins coach Bill Schmeisser. Club lacrosse continued as an amateur club throughout its history until the early 1970s, when it was displaced by professional lacrosse. Next door, the Meadowbrook Pool started as a favorite summer pastime but has evolved into a year-round aquatic and fitness facility.

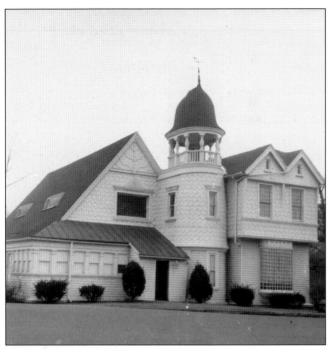

THE MOUNT WASHINGTON CASINO, 1909. This building was first named the Mount Washington Hall, designed by Dr. J.A. and W.T. Wilson, architects, and built by Henry A. Nagle, contractor, in 1883 for a cost of $5,500. It was located on South Avenue (now Sulgrave). In 1914, the community leased the Casino from the Mount Washington Company for a period of 30 years and held dances and theatrical performances there. After World War II, club membership declined, and the Casino was no longer the social hub, as it had been in its earlier days. The building fell into disrepair and was razed in 1958. (Courtesy of the Mount Washington School.)

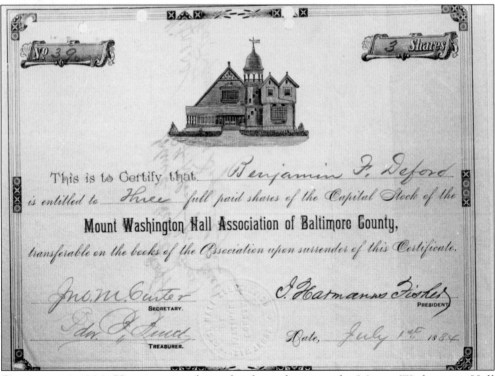

CERTIFICATE, 1884. Here is a certificate for three shares in the Mount Washington Hall Association of Baltimore County issued to Benjamin F. DeFord. The building on the certificate is the Mount Washington Casino. (Courtesy of the Photograph Collection of the Baltimore County Public Library.)

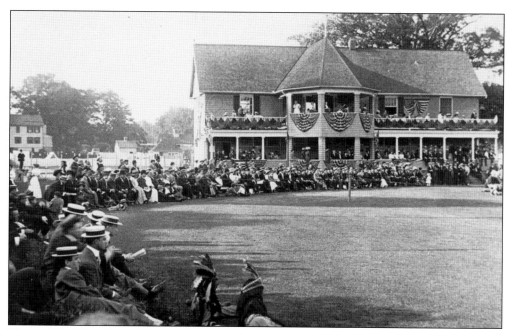

NORRIS FIELD CLUBHOUSE. A large crowd is seen seated on the lawn at the clubhouse waiting for an unspecified event to begin. The picture was probably taken on the Fourth of July, judging by the bunting displayed on the railings of the old clubhouse. A new brick clubhouse was constructed later on the Meadowbrook property that better served the social and athletic needs of the community. (Courtesy of the Photograph Collection of the Baltimore County Public Library.)

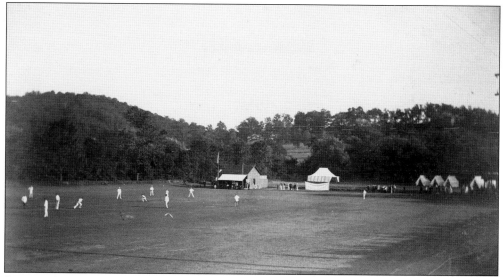

CRICKET GAME. In this photograph, a Mount Washington cricket game is in progress on Norris Field. It shows the players dressed in white and a clubhouse with tents for changing and refreshments. This photograph was taken from the vicinity of the Northern Central Railway tracks. According to local historian Mark Miller, "As early as 1876, passengers riding the cars of the North Central could watch cricket matches on the fields just east of the railroad tracks." (Courtesy of the Photograph Collection of the Baltimore County Public Library.)

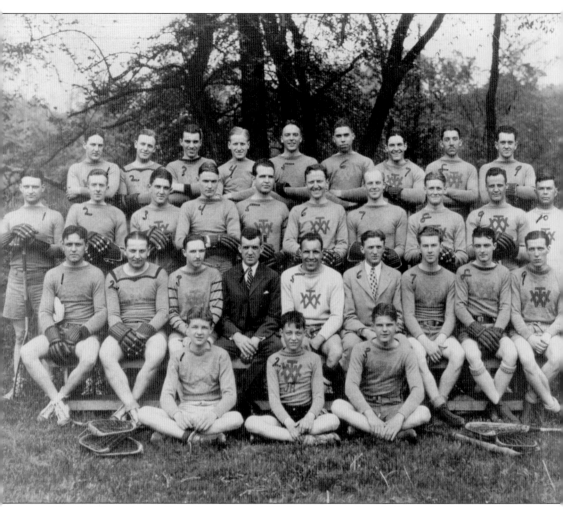

Mount Washington Club Lacrosse, 1920. Pictured are, from left to right, (first row) Hunkie LaMotte, Marshall Jones Jr., and Gibby La Motte; (second row) Milt McDaniel, Dick Miller, unidentified, Gibbs LaMotte, Ots Tower, Rus Myers, C. Miller, and Duke Gunther; (third row) Bob Brady, Cas Wylie, Lou Huppman, Heintz Burnham, Ed Allen, Fred Wehr, Ed Stinson, Oster Norris, Fen Baker, and Mal Keech; (fourth row) Lindsay Huppman, Brooke Shehan, Delly Hautsche, Paul Norris, Emil Budnitz, Bill Pirie, Doug Turnbull, Hall Duncan, and Tubby Slearman. (Courtesy of the Lacrosse Museum and National Hall of Fame.)

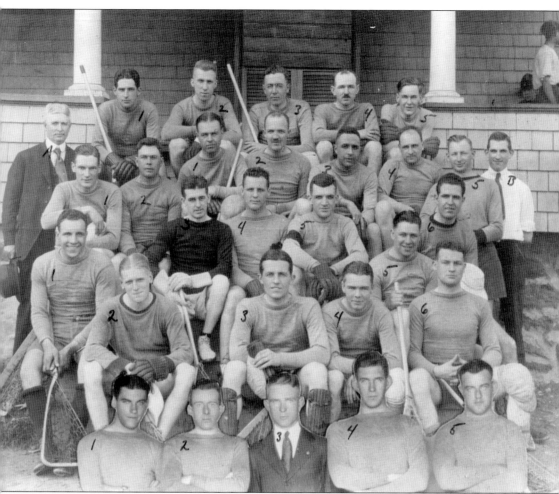

LACROSSE TEAM, 1921. Pictured are, from left to right, (first row, inset) Boots Barrett, Cas Wylie, Tommy Troxell, Benson Dushane, and Don Meikle; (second row) Ots Tower, Wentworth Norris, Ed Stuart, Chauncey Pyle, Temple Joyce, and Jim Stevens; (third row) Clagett Pyle, Mal Keech, Canadian team coach Harney, Fen Baker, Gibbs LaMotte, and Ed Allen; (fourth row) Webster Abbott, Ed Fitch, Herb Grymes, Tubby Sutton, and Bradford Blake; (fifth row) Ferd Meyer, Herb Baxley, Carl Schmidt, Ed Gripen Kurl, and Willis Paul; (standing on each side) a Mr. Norris (A) and Dixie Sheridan (B). (Courtesy of the Lacrosse Museum and National Hall of Fame.)

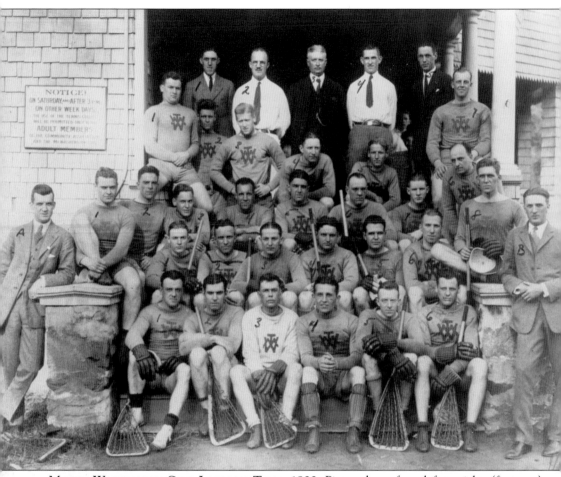

MOUNT WASHINGTON CLUB LACROSSE TEAM, 1922. Pictured are, from left to right, (first row) Don Meikle, Boots Barrett, Mal Keech (captain), Ed Stuart, Cas Wylie, and Fen Baker; (second row) Heintz Burnham, Larry Baldwin, Dick Miller, Robert Brady, Ed Allen, and Herb Baxley; (third row) Gene Callis, Emil Budnitz, Willis Paul, Ots Tower, Lou Huppman, Bob Magruder, ? Wylie, and Bens Dushane; (fourth row) Jim Stevens, Oster Norris, Wentworth Norris, Bill Healy, Paul Norris, Tubby Sutton, and Ed Stinson; (fifth row) Edward Cole, Ed Fitch, Harry O. Norris, Richard Sheridan, and Kensett Pyle; (standing on each side) Gibbs LaMotte (A) and Rus Myers (B). (Courtesy of the Lacrosse Museum and National Hall of Fame.)

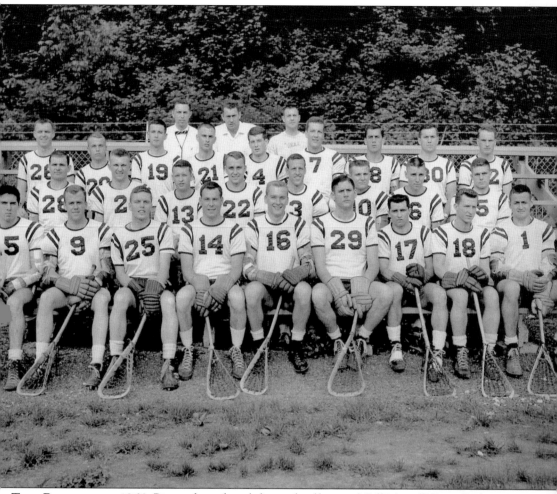

TEAM PHOTOGRAPH, 1960. Pictured are, from left to right, (first row) Bill Morrell, Buzzy Budnitz, Tom Moore, Bud Waesche, Ben Goertemiller and Furlong Baldwin (cocaptains), Joe Seivold, Al Seivold, and Bob Schlenger; (second row) Roger Doyle, Bud McNicholas, Jim Kappler, Bill Campbell, Charles Obrecht, Ab Tiedemann, Bob Hachtel, and Pete Bouscaren; (third row) Bob Merrick, Bob Adair, Trent Colt, Ross Parham, Mickey McFadden, Chuck Franklin, Junior Kelz, Jack Polhaus, and Stu Carlisle; (fourth row) Bill Keigler, Leo Mueller, and Bo Willis (coaches). (Courtesy of the Lacrosse Museum and National Hall of Fame.)

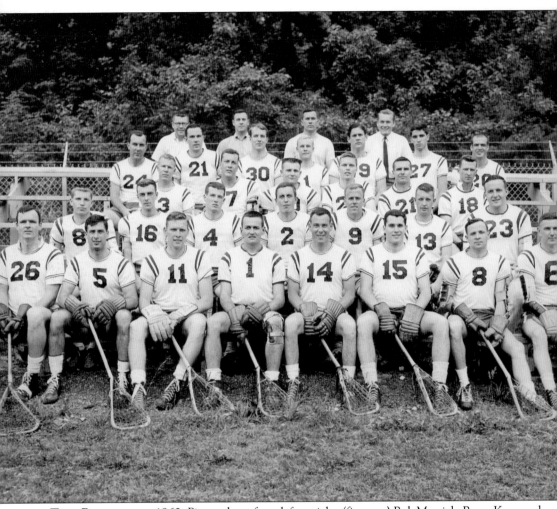

TEAM PHOTOGRAPH, 1962. Pictured are, from left to right, (first row) Bob Merrick, Buzzy Krongard, Al Seivold, Bob Schlenger, Jon Taylor, Larry Becker, George Boynton, and Pete Powell; (second row) Bill Whiteford, David Cordish, Butch McCleary, Buzzy Budnitz, Jim Kappler (cocaptain), and Tom Biddison; (third row) Jerry Amlong, Chuck Franklin, Ab Tiedeman, and Mickey McFadden (cocaptain); (fourth row) Gene Reckner, Bob Becker, Bob Schlenger, Harold Grosh, Cy Horine, and Frank Riggs; (fifth row) Spike Watts (manager) and Ben Goertemiller and Jack Polhaus (coaches). (Courtesy of the Lacrosse Museum and National Hall of Fame.)

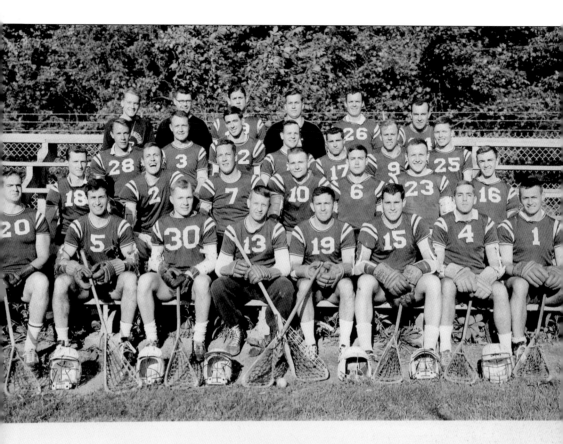

MT. WASHINGTON CLUB
1963

TEAM PHOTOGRAPH, 1963. Pictured are, from left to right, (first row) Frank Riggs, Buzzy Krongard, Bob Becker, Jim Kappler (cocaptain), Harold Grosh, Larry Becker, David Cordish, and Bob Schlenger; (second row) Mickey Di Maggio, Butch McCleary, Chuck Franklin, Ab Tiedemann, Pete Powell, Tom Biddison, and Bill Whiteford; (third row) Bob Gaines, Jerry Amlong, Randy Walker, George Boynton, Joe Seivold, Buzzy Budnitz, and Tom Moore; (fourth row) Jack Polhaus (coach), Spike Watts (manager), George Boynton, Ben Goertemiller (coach), Bob Merrick, and Gene Reckner. (Courtesy of the Lacrosse Museum and National Hall of Fame.)

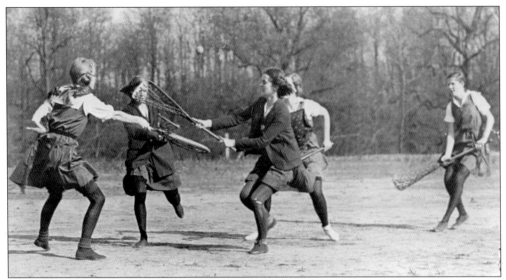

Bryn Mawr Girls' Lacrosse Game at Norris Field. The Bryn Mawr School for Girls in Baltimore City was founded in 1885. In 1926, Rosabelle Sinclair established the first American women's lacrosse team at Bryn Mawr School for Girls, bringing the game to the United States from St. Leonard's School in Scotland. In 1992, she was the first woman inducted into the National Hall of Fame. (Courtesy of the Bryn Mawr School for Girls.)

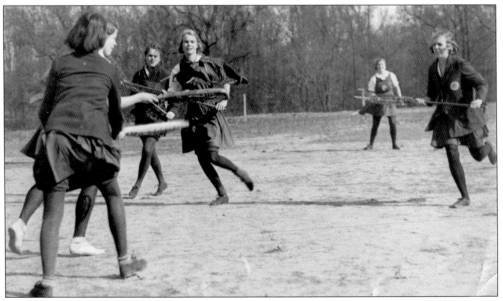

Girls' Lacrosse. Mount Washington has shared its home field, Norris Field on Kelly Avenue, with the all-girls Bryn Mawr School. In 1999, the Mount Washington Lacrosse Club sold Norris Field to the Bryn Mawr School for $250,000. Both entities agreed to a 20-year contract to share the facilities, with the club having access at night for practice and on weekends for games. (Courtesy of the Bryn Mawr School for Girls.)

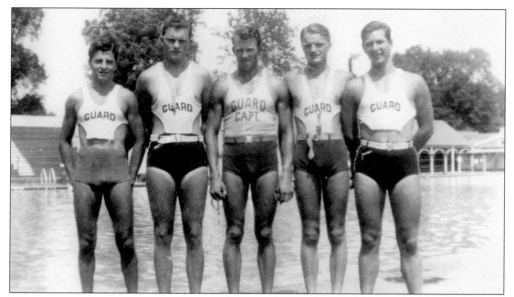

MEADOWBROOK LIFEGUARDS, C. 1930. Built by the George Morris Company, Meadowbrook Pool opened in June 1930 and was the first privately owned pool of its size in the area. Ben Evans, head guard and swimming instructor in the 1930s, recalled in a *Sun* magazine issue on June 22, 1969, that "During a long hot spell in 1930, the water temperature rose into the 80s. To lower it, we dumped 30 cakes of ice into the pool. We were amazed to find it only lowered the temperature less than two degrees." (Courtesy of Meadowbrook Aquatic & Fitness Center.)

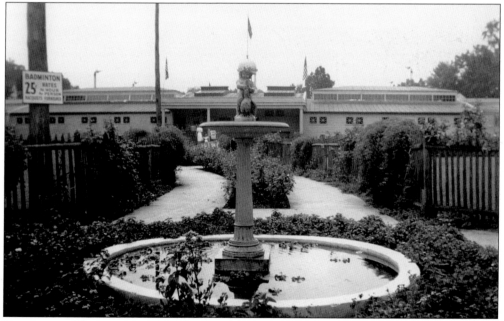

FOUNTAIN AT MEADOWBROOK. This fountain was once a focal point in the walkway to the clubhouse at Meadowbrook Swim Club. Some members recall the elaborate rose gardens lining the walk from the Kelly Avenue viaduct that split to go around the fountain. In the background is the clubhouse. A cupola topped the center of this building, and there were five flagpoles flying American flags for the club's opening in June 1930. (Courtesy of Meadowbrook Aquatic & Fitness Center.)

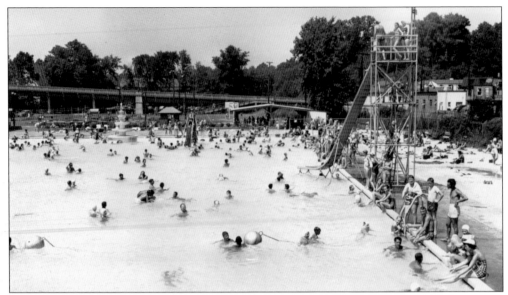

COOLING OFF AT MEADOWBROOK. Meadowbrook Swim Club became a favorite spot for Baltimoreans to escape the summer heat. The establishment of an electric streetcar line up Falls Road, across the confluence of the Jones Falls and Western Run, past Washingtonville, and into the village of Mount Washington provided transportation to Meadowbrook for thousands of Baltimore families. A wooden bridge over the Jones Falls served to carry swimmers from Falls Road to the club. (Courtesy of Meadowbrook Aquatic & Fitness Center.)

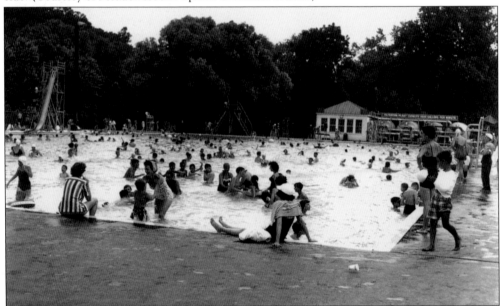

CELEBRITY SWIMMERS. During the 1930s, Meadowbrook became a showplace for diving and swimming competitions and exhibitions given by and including such notables as Buster Crabbe and Johnny Weismuller. Writer F. Scott Fitzgerald is known to have spent some afternoons on Meadowbrook's white-sand beaches. Olympic swimmers Michael Phelps and Anita Nall are two of many professional swimmers who trained here. (Courtesy of Meadowbrook Aquatic & Fitness Center.)

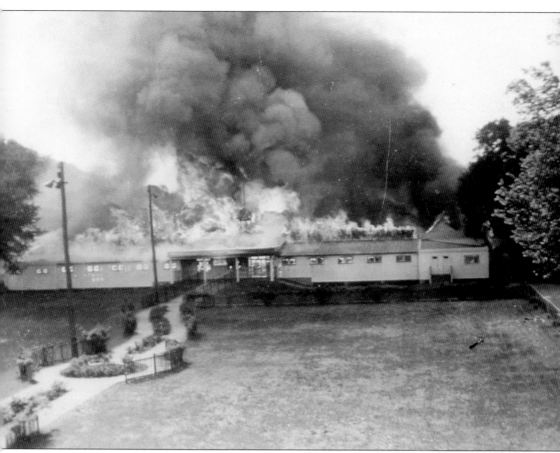

FIRE AT MEADOWBROOK. In May 1944, the elegant wooden structures built in 1930 went up in an unexplained fire. The pool manager, Julius Ziegfeld, was preparing the big outdoor pool for the next weekend's opening when he noticed smoke and flames coming from the buildings. Nine engine companies and three trucks called to the scene could not save the complex. In 1945, Edith Stieber and Frank Roberts purchased the pool and surrounding lands from George Morris. In 1986, Murray Stephens and his wife, Patricia, purchased the property. (Courtesy of Meadowbrook Aquatic & Fitness Center.)

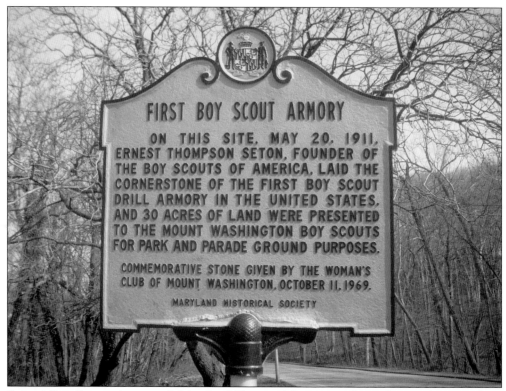

SITE OF BOY SCOUT ARMORY. A Maryland Historical Society marker indicates the spot where once stood a stone house used as the Boy Scout Armory. On May 20, 1911, the cornerstone was laid for the armory, which was built with materials from the old snuff mill that once stood at Kelly Avenue and Cross Country Boulevard. In the mid-1960s, the ruins were cleared, and the land was designated as a historical site. (Author's collection.)

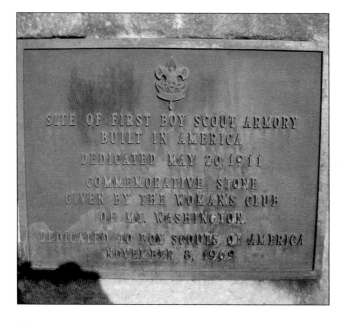

COMMEMORATIVE STONE. The Woman's Club of Mount Washington provided the stone and plaque for the armory site in a dedication ceremony on November 8, 1969. In an article dated November 26, 1910, in the *Baltimore County Union*, it was noted that "a number of battalions of the Boys' Brigade participated in a make-believe battle at Mount Washington. After the 'fighting,' the participants enjoyed a meal of real army fare—beans and hardtack—which they ate with evident relish. Footraces and a game of baseball concluded the sports of the day." (Author's collection.)

Six

CARING FOR OTHERS

Hortense Kahn Eliasberg's interest in young convalescents was sparked by her medical social work at Sinai and Johns Hopkins Hospitals. Engaged in Baltimore social work in 1921, Hortense Kahn Eliasberg discovered the need for a convalescent home for children. The enthusiastic support by local pediatricians helped endorse her vision of Happy Hills Convalescent Home for Children, known today as Mount Washington Pediatric Hospital. An article in the *Baltimore Sun* newspaper in 1922 described it as follows:

> Happy Hills is not a hospital; still less it is an institution. It is a home for convalescent children. The general hospitals cannot afford to keep their patients after they have been cured. Yet it is important that those whose who have won in a struggle with disease should have the best care during the period of recovery.

In 1928, it became apparent that more and larger facilities were necessary. In April 1928, the trustees purchased the property formerly known as the Whitelock estate on Rogers Avenue for $35,000. It consisted of 23.4 acres, including a home, a Swiss chalet, a barn, a toolhouse, and a chicken house. The mansion was renovated, and a new fireproof building was erected at cost of $100,000, offering 90 beds in preparation for its opening in 1930. Two of the sunny wards were devoted entirely to children recovering from rheumatic fever and heart disease.

Other caring institutions included the Wesley Home, a Methodist-based home for the aged, which is known today as Springwell Senior Living Community. Springwell, located on the grounds of the old Prestwolde estate on Rogers Avenue, offers excellent accommodations for several levels of care: independent living, assisted living, and memory care. Nearby Sinai Hospital and Levindale Hebrew Geriatric Center and Hospital join Mount Washington Pediatric Hospital and Springwell in their missions to incorporate the values of family centeredness into every aspect of care.

"WHEN A FELLER NEEDS A FRIEND." This cartoon was used in a Happy Hills appeal campaign for funding. Briggs, the cartoonist, was asked for a contribution, and he sent along a drawing on May 23, 1923. Social worker Hortense Kahn founded Happy Hills in 1922 with the support of various medical professionals. Financial support for the home came from various fundraising campaigns, Blue Cross and other medical programs, welfare, and parents' stipends, while an important share was sustained by the Community Chest. (Courtesy of the Mount Washington Pediatric Hospital.)

WILLIAM H. WELCH. This bronze plaque of Dr. William H. Welch, dean of the Johns Hopkins Medical School and one of the founders of the institution, was unveiled in his memory at the new Happy Hills location on June 4, 1935. Dr. Welch had served as the home's first and only president of its board of trustees. When the new facility opened on Rogers Avenue in 1930, Benjamin Frank, architect, presented the keys to Dr. Welch, at which time he expressed his appreciation for community support as follows: "The children, many of them from poor and improper homes, are in a healthy environment where they get good food and plenty of fresh air. The people supporting this home are making a contribution to one of the most urgent civic needs of Baltimore." After the ceremony, the party adjourned for tea and an inspection of the home. Notables in attendance were Hortense Kahn Eliasberg, founder of Happy Hills, and writer Ogden Nash, a resident of Mount Washington at the time. (Courtesy of the Mount Washington Pediatric Hospital.)

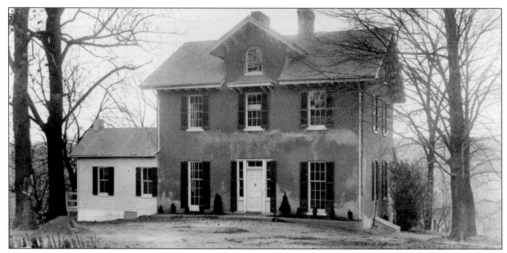

HAPPY HILLS CONVALESCENT HOME FOR CHILDREN. Originally part of the Socrates estate, Edward Morris donated the land and a brick Colonial house for the Happy Hills Convalescent Home for Children on Falls Road near Belvedere Avenue from 1922 to 1930. There were accommodations for 20 children. During the first year of operation, about 100 children recuperated from various ailments such as rheumatic heart disease, tuberculosis, asthmatic conditions, malnutrition, and other ailments. In 1930, the home moved to a larger site on the old Whitelock estate on Rogers Avenue to accommodate the increasing needs of convalescent care for children. (Courtesy of the Mount Washington Pediatric Hospital.)

DINNERTIME AT HAPPY HILLS. In a news article from the 1920s, the dinnertime routine was captured so eloquently as follows: "It was dinner time at Happy Hills. Into the house they romp and to the washrooms for clean hands and faces. At last they are seated in the dining room, the small children on tiny chairs at a miniature table, the older ones nearby at an ordinary size table. At each place is a white mug with blue band with blue and white table mats." (Courtesy of the Mount Washington Pediatric Hospital.)

DOLLS, MAGAZINES, TOYS, AND GAMES. This is a photograph of a young girl with her doll who could no doubt be a Happy Hills poster child. In addition to the healthy diet and excellent medical care at Happy Hills, other activities helped bring the children back to health as well. The following was written about Happy Hills in a *Sunday Sun* newspaper article dated July 12, 1925: "Playground activities in the summer and schoolwork in the winter, dolls, magazines, toys, and games keep the youngster satisfied and bring them back to health. Happy Hills is a home for children who have been sick and are trying to get well quickly. These children come from various hospitals of Baltimore and stay in the lovely country home until they are quite normal and healthy after their illness. On rainy days, the little girls brought their dolls in the house and played hospital. Each doll was very sick at the beginning of a rainy afternoon, but in the end, it has been brought to Happy Hills and cured just as its mother was." (Courtesy of the Mount Washington Pediatric Hospital.)

Happy Hills is a dear, dear place for you and me. It
makes you well it makes you strong for-ev-er be. All the
children are friends with you When you learn to love them too
We will always re-mem-ber you Hap-py Hills

HAPPY HILLS SONG. Records do not indicate the writer of this song, but it most likely the work of a young Happy Hills patient. In winter, children transferred to School No. 352 at Happy Hills so they could keep up with their schoolwork. The Department of Education staffed teachers at the facility. However, in summer, school was abandoned, and there was a playground teacher to supervise games and dances and songs. (Courtesy of the Mount Washington Pediatric Hospital.)

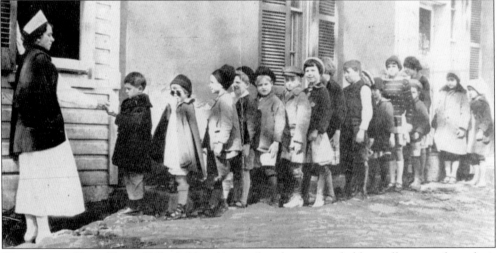

VACCINATION TIME. Happy Hills children line up for what was probably smallpox or tuberculosis vaccines. In spite of the fact that most of the children arrived at the home in very poor physical condition, every child left Happy Hills greatly improved. (Courtesy of the Mount Washington Pediatric.)

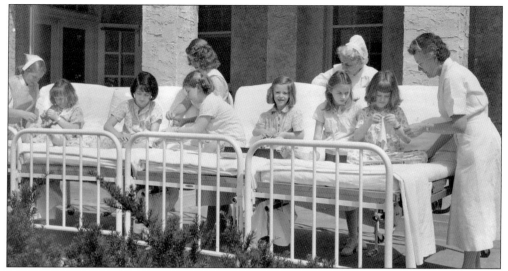

DAILY ROUTINE. A daily routine for the "very fortunate young people at Happy Hills" was described in an article in the July 12, 1925, issue of the *Baltimore Sunday Sun* as follows: "The children were awakened at 6:30 a.m. and had exercises outside in warm and cold weather, cold showers and then breakfast. The girls learned household duties and all children then prepared for school. Several glasses of milk, sunbaths, and naps made up the afternoon schedule. Supper would consist of nourishing meals after which hot baths were given and bedtime was scheduled at 7 p.m." (Courtesy of the Mount Washington Pediatric Hospital.)

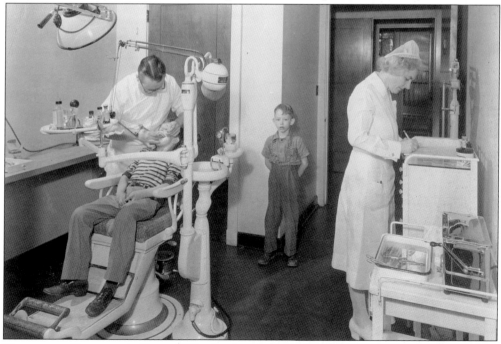

TRIP TO THE DENTIST. At Happy Hills, the dental clinic played an important role as part of the health care program for the children. Thelma G., the first patient admitted on July 11, 1922, with a diagnosis of empyema (a lung disease), was prescribed "one quart of milk and two eggs with moderate exercise" everyday. (Courtesy of the Mount Washington Pediatric Hospital.)

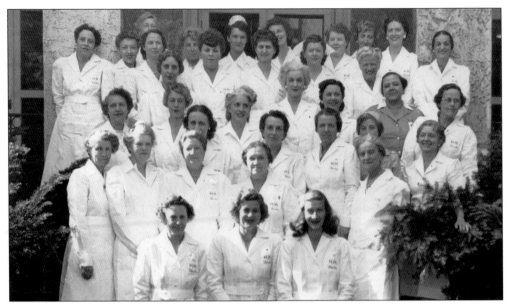

VOLUNTEER NURSING STAFF. This staff of volunteer nurses helped carry the burden during the shortage of nurses during World War II. The Happy Hills nursing staff was an important element in the recovery process of the children, both physically and emotionally. Whether recovering from an acute illness or serious surgical operation, children needed skilled nursing care and medical advice to aid in their recovery process. In 1938, the Swiss chalet at the Rogers Avenue location was remodeled as a home for nurses. (Courtesy of the Mount Washington Pediatric Hospital.)

POSTCARDS, 1949. The children at Happy Hills enjoyed many social activities such as shows, concerts, and visits from local civic organizations, schools, and celebrities. Local WFBR radio personality Henry Hickman looks on as young patients enjoy sifting through a rather large volume of postcards from world travelers. (Courtesy of the Mount Washington Pediatric Hospital.)

FUN ON THE CAROUSEL AT DRUID HILL PARK ZOO. What better orders from the doctor than an outing to Druid Hill Park, located in northwest Baltimore. In 1860, Lloyd Rogers sold his property to the city to create a park with lakes, scenic views, picnic groves, pathways, and promenades. Druid Hill is now in the National Register of Historic Places. Its most well-known elements are the man-made Druid Lake and the Maryland Zoo. (Courtesy of the Mount Washington Pediatric Hospital.)

TRAIN RIDES AT DRUID HILL PARK. Just what the doctor ordered for children from Happy Hills and their families—train rides at Druid Hill Park in the summertime. The children, along with their parents, enjoyed special outings at Druid Hill Park. The park was Baltimore's first large municipal park and is known for its beautiful foliage, waterscapes, and the world-famous Maryland Zoo, home to over 2,000 animals. (Courtesy of the Mount Washington Pediatric Hospital.)

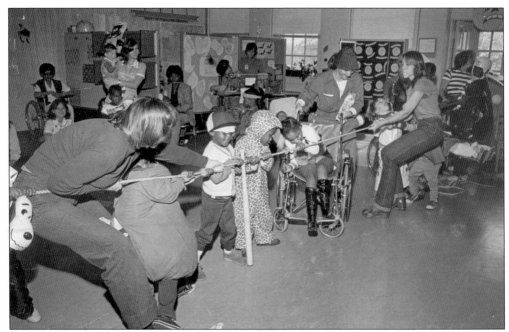

TUG-OF-WAR CONTEST. The Happy Hills staff always made sure there were lots of fun activities for the children. Games and toys, playground equipment, sandbox play, sledding, and various other activities were part of the healing process at Happy Hills. Recreational fun was just as therapeutic as medical care at the home. (Courtesy of the Mount Washington Pediatric Hospital.)

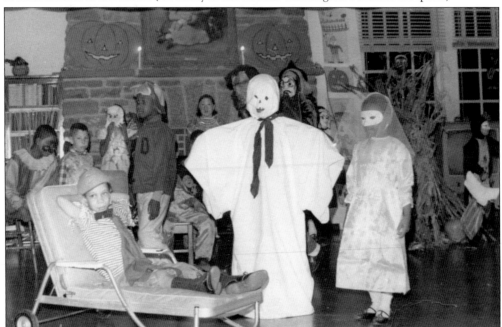

HALLOWEEN PARTY. Children enjoyed dressing up in costume for Halloween parties at Happy Hills. Activities such as Christmas pageants, eggs and candy at Easter, May marts, and holiday concerts were always a part of life at Happy Hills. Families and friends joined in the fun, too. (Courtesy of the Mount Washington Pediatric Hospital.)

CHRISTMAS AT HAPPY HILLS. "And the stockings were hung by the chimney with care, with the hope that St. Nicholas soon would be there"—and St. Nick always visited Happy Hills with presents for everyone. Christmas and other holidays were special occasions for the children at Happy Hills. This photograph appeared on the cover of a Christmas card from Happy Hills in 1966. (Courtesy of the Mount Washington Pediatric Hospital.)

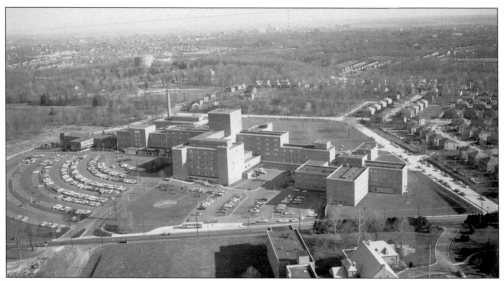

OVERVIEW OF SINAI HOSPITAL, c. 1959. Sinai institutions date back to 1863 when the Hebrew Benevolent Society opened a facility in downtown Baltimore. Because of both the living conditions and the state of the healing arts, health care was insufficient to meet the community's needs. In 1910, almost half of those who applied to charitable hospitals were tubercular. To serve the health needs of the community, the Jewish communal leadership founded the Hebrew Hospital and Asylum (later Sinai Hospital) and moved to this location on West Belvedere Avenue in 1959. (Courtesy of the Baltimore Museum of Industry.)

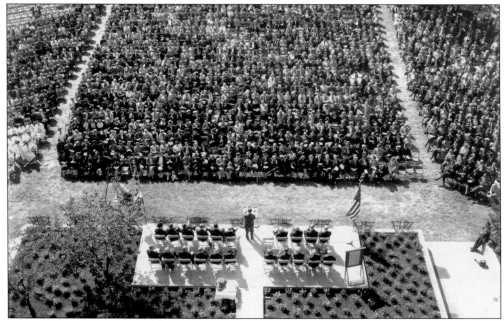

GRAND OPENING, SEPTEMBER 20, 1959. Sinai Hospital opened at this location on West Belvedere Avenue in 1959 with parking spaces for 800 and a heliport at its new location. The present location once housed an orphanage founded in 1923. Sinai is a Jewish-sponsored health care organization providing services for all people. Since 1998, Sinai Hospital has been a part of the LifeBridge Health system. (Courtesy of LifeBridge Health.)

ENGRAVING OF THE NEW WESLEY HOME. The original Wesley Home stood at the corner of Fulton Avenue and Franklin Street in downtown Baltimore. The home's earlier beginnings were attributed to Dr. George Milton Roberts, renowned doctor and surgeon in Baltimore, who opened his parsonage in 1867 for elderly women who had lost their husbands during the Civil War. The new Wesley Home was built at Prestwolde, the 15-acre estate on West Rogers Avenue in Mount Washington. E.D. Bruce, who was engaged in distilling liquors and importing wines, built Prestwolde as a summerhouse for his wife. Bruce suffered from depression and committed suicide in 1900. (Courtesy of Springwell Senior Living Community.)

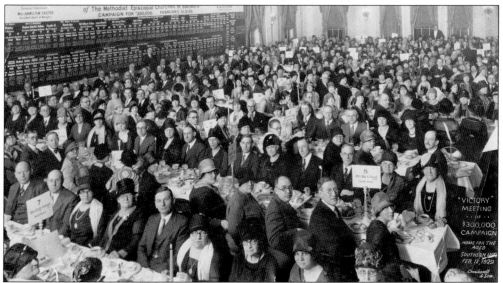

VICTORY MEETING, 1929. In 1928, the heirs of E.D. Bruce sold the property to the Methodist Episcopal Church for a sum of $65,000 for the construction of a new Home for the Aged of the Methodist Episcopal Church on this site. A campaign was initiated on February 1, 1929, to raise $300,000 in funds for the construction of a new brick building. Over 50 Methodist Episcopal Churches of Baltimore responded to the campaign, and the funds were raised in seven days and were secure from the eminent depression. On February 11, a Victory Meeting, shown here, was held at the Southern Hotel. (Courtesy of Springwell Senior Living Community.)

FRONT FACADE, WESLEY HOME. The Prestwolde Mansion was demolished, and ground was broken on November 16, 1930, for the construction of a 240-room redbrick building, costing around $500,000, which included equipment. The cornerstone was laid on May 24, 1931, at 4:00 p.m., and after completion, a dedication service was held on November 16, 1931, in the newly constructed chapel. Over 100 residents, their beds, furnishings, and clothing, as well as the home's furniture and equipment, were moved from the Franklin Street home in phases. (Courtesy of Springwell Senior Living Community.)

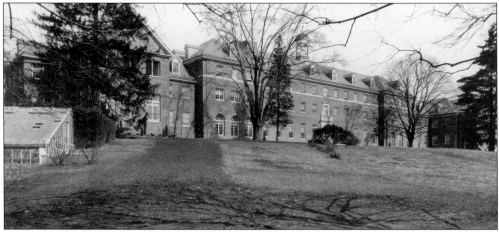

ANOTHER VIEW OF THE FRONT FACADE, WESLEY HOME. In 1931, applicants to the home had to meet strict qualifications. The applicant had to be "at least 65 years of age, must have been a member of the Methodist Church in Baltimore for not less than ten years, and must be ambulatory and without trace of mental disorder." Each applicant was also required to have two sponsors who would vouch for his or her good standing in the community and church. (Courtesy of Springwell Senior Living Community.)

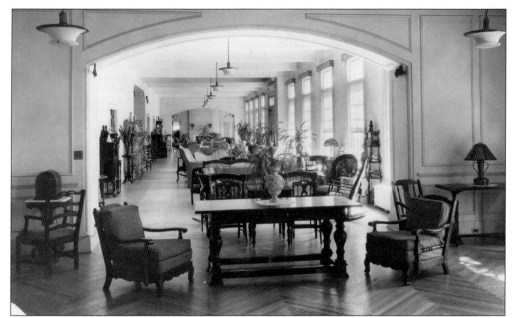

MAIN HALL. The main hall contained many pieces of furniture and art objects that were given by residents to the home before and following the move. Residents gathered in the main hall for conversation, entertainment, and special activities. The Wesley Guild was the term given to the volunteer women who put the "sparkle" in the home. This guild is still active at Springwell today. (Courtesy of Springwell Senior Living Community.)

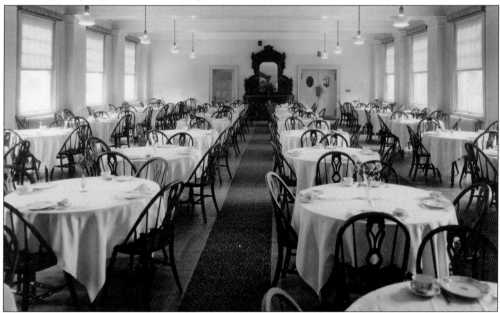

DINING ROOM. The daily operation of the Wesley Home was the responsibility of the Woman's Board of Managers. They were responsible for the daily care of the home, its furnishings, housekeeping, food service, medical care, grounds, interviewing guests, and various recreational activities. The board of trustees had the responsibility for the home's physical and financial property, repairs, replacements, insurance, and investment of its securities. (Courtesy of Springwell Senior Living Community.)

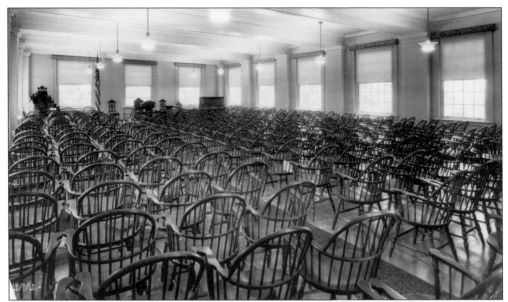

MEETING ROOM. In 2007, due to extenuating financial circumstances, the Wesley Home had only 30 residents. Some churches had no members at the Wesley, and their financial support declined. The Wesley Home, after a history of 140 years, was in decline. The wilting spirit of the Wesley Home was reborn in May 2008, when John Chay rejuvenated it as "Springwell—A Senior Living Community." Springwell currently has 125 residents and 120 employees. (Courtesy of Springwell Senior Living Community.)

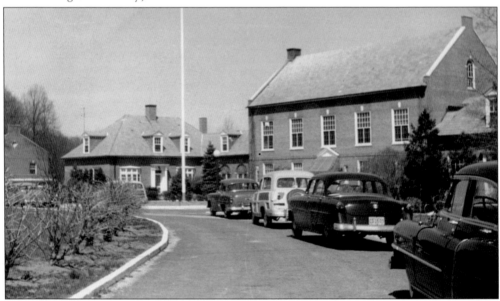

LEVINDALE HEBREW GERIATRIC CENTER AND HOSPITAL. The area of Levindale consists of the Hebrew Geriatric Center and Hospital, Sinai Hospital, and 10 residential blocks. Sinai institutions date to 1863, when the Hebrew Benevolent Society opened an institution in east Baltimore at Broadway and Monument Street. Levindale Hebrew Geriatric Center and Hospital Home and Infirmary, an institution for the elderly, was named after Louis H. Levin, Baltimore editor of the *Jewish Comment*. (Courtesy of the Mount Washington School.)

Seven

PIMLICO GOOD NEIGHBORS

Similar to Mount Washington, modern Pimlico evolved from 800 acres called Pemblicoe, surveyed and patented in the late 17th century and owned by John Oldham, captain of the Baltimore County Rangers. The area known as Pimlico Good Neighbors primarily consists of the Pimlico Racetrack and 22 residential blocks. The main thoroughfare of Park Heights Avenue followed the path of an old rail line into Baltimore County. Between 1908 and 1950, duplexes, detached homes, and row houses lined the streets of Pimlico near the Park Heights Avenue streetcar line. In the 1930s and 1940s, Pimlico was a "walk-to" neighborhood with stores, churches, library, and post office approximately located within a two-block area of one's home, intermingled with row houses at the intersection at Park Heights and Belvedere Avenues. Of all the commercial centers that developed along the Park Heights corridor in its golden age, Pimlico was the largest, busiest, and the most diverse with two movie houses.

The Pimlico Racetrack was the attraction that really put Pimlico on the map. Gov. Oden Bowie is the man credited with bringing horse racing to Baltimore. While attending a dinner party with other fellow racing enthusiasts at the Union Hotel in Saratoga, New York, there was discussion about where to build a state-of-the-art track. Governor Bowie knew exactly where he planned to build a track in Maryland. A few years later, on October 26, 1870, the horses broke from the starting gate at Pimlico, marking Baltimore's first race. The inaugural race was named the Dinner Party Stakes, after the dinner party at which the idea of the track had been conceived. Its winner was named Preakness, a colt from a New Jersey village by the same name. On May 27, 1873, nearly 12,000 people cheered the first Preakness Stakes at Pimlico. It was not until the year 1917 that the coveted Woodlawn Vase, designed by Tiffany & Co., Inc., was presented to the winner of the Preakness. It has been regarded as the middle jewel in racing's fabled Triple Crown, a succession of three races within five weeks since the 1930s. As stated by local historian Gilbert Sandler, "Pimlico the sports destination and Pimlico the neighborhood would always be bound together."

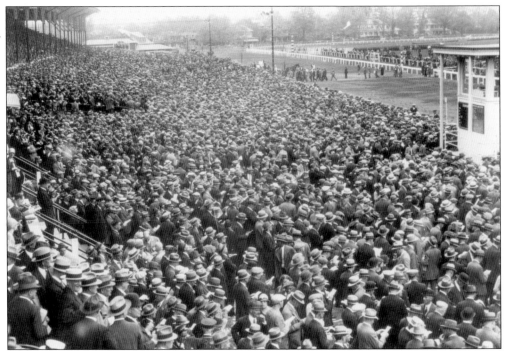

A DAY AT "OLD HILLTOP." In the early 20th century, racing enthusiasts traveled by streetcar and rail from downtown hotels to Pimlico Racetrack in northwest Baltimore for a day at the races. By the 1930s, Pimlico had its own hotels, rooming houses, inns, and restaurants for the racing crowd. The track's nickname, "Old Hilltop," came from a rocky mound that once stood in the middle of the infield. It was finally leveled in 1938. (Courtesy of the Baltimore Museum of Industry.)

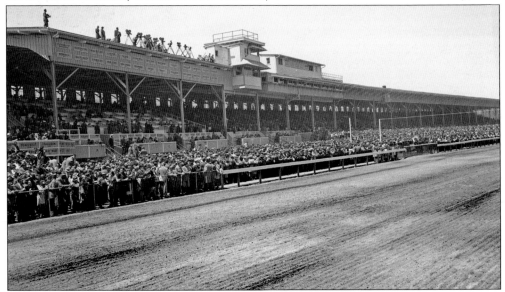

VIEW OF THE GRANDSTANDS. Some well-known horses ran at Pimlico. Man o' War ran his first race as a three year old at Pimlico in 1920. Gallant Fox captured the Triple Crown in 1930. Citation brought racing to television in 1948, and Secretariat nearly broke a track record in 1973. (Courtesy of the Photograph Collection of the Baltimore County Public Library.)

POST TIME AT PIMLICO.
Pimlico's Victorian-style
clubhouse (in the distance)
was the nation's oldest
until it burned in 1966.
The clubhouse went up
in flames in an eight-
alarm blaze in 1966. The
Steamboat Gothic-era
members' clubhouse had
been host to generations
of race-goers who gathered
on broad porches and in its
dining rooms, clubrooms,
and parlors to urge on
some legends in horse
racing. (Courtesy of the
Photograph Collection
of the Baltimore County
Public Library.)

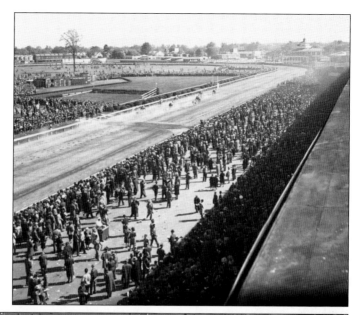

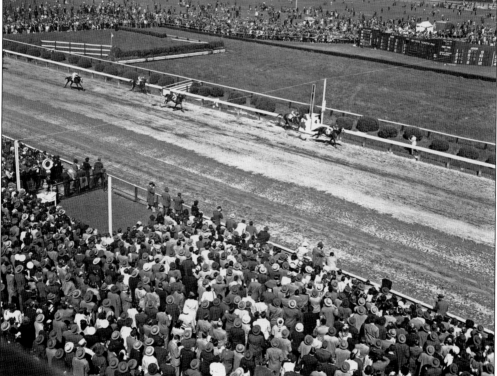

WIN, PLACE, AND SHOW. Local enthusiasts regard the Preakness as the best of three races in the Triple Crown. One of the most noted match races in sporting history was staged at Pimlico Racetrack on November 1, 1938. Jockey George Woolf rode Seabiscuit to a decisive victory over War Admiral in a two-horse contest called the Pimlico Special. Woolf often referred to Seabiscuit as "the greatest horse I ever rode." (Courtesy of the Photograph Collection of the Baltimore County Public Library.)

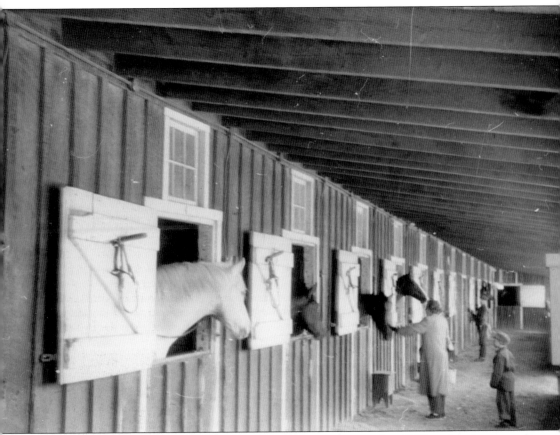

GROOMING STABLES. The Maryland Jockey Club was organized in 1830, and jockeys raced at other locations prior to the Pimlico opening in 1870. Between 1890 and 1904, the club sold the property and ceased to sponsor the races at Pimlico. The clubhouse became home to the Pimlico Driving Club and to the Country Club of Baltimore County, a social club. By 1904, the Maryland Jockey Club was back at Pimlico. The National Jockeys Hall of Fame was founded at Pimlico in 1955. (Courtesy of the Mount Washington School.)

HAMILTON FAMILY OUT FOR DRIVE, 1911 OR 1912. Due to the horrible condition of Falls Road before it was paved, some residents traveled through Druid Hill Park and Pimlico to reach Mount Washington. Among the passengers in this touring car are Donald Hamilton, James Allan Hamilton, Stewart Hamilton, and Minnie Hamilton (Mrs. Allan Hamilton), brothers and sister-in-law of Robert Bruce Hamilton Sr. (Courtesy of the Photograph Collection of the Baltimore County Public Library.)

WAAM 13 RADIO STATION. Baltimore's third television station started on November 2, 1948, as WAAM and was owned by a pair of Baltimore businessmen, brothers Ben and Herman Cohen. Westinghouse Electric Corporation purchased WAAM from the Cohen brothers in 1957 and renamed it WJZ-TV. Here, commentator Ken Coffey prepares for a segment on "melmac"—plastic dinnerware found in many homes from the 1940s to 1970s; it is highly collectible now. At that time, WJZ-TV was one of three television stations providing service to homes in northwest Baltimore. (Courtesy of Gerald Yamin.)

• Today's Suggestions •

Robbins Island Oysters on Half Shell (6) 30
Cherry Stone Clams on Half Shell (6) 20
Clams on Half Shell (6) 25
Cocktail Sauce 5c Extra

Mixed Fruit	10	Tomato Juice Cocktail	05
Chicken Soup	10	English Beef Soup	10

PLATTERS

Chicken Pie en Casserole 25
Breaded Veal Cutlet (Tomato Sauce)
 Creamed Fresh Broccoli, Mashed Potatoes 35 40
Hot Roast Turkey Sandwich (Giblet Gravy), Filling
 and Cranberry Sauce 35, with Potatoes 40
Roast Young Turkey (Giblet Gravy), Filling
 Cranberry Sauce, Buttered Peas,
 Parsley New Potatoes, Roll and Butter 60
Creamed Chicken and Mushrooms on Toast
 and Fresh String Beans 35
Tenderloin Steak
 Fresh Spinach, Baked Potato 50
Roast Prime Ribs of Beef au Jus
 Fresh Brussels Sprouts, Mashed Potatoes 40
Virginia Baked Ham (Glazed Apples)
 Harvard Beets, Candied Sweet Potatoes 40
Fresh Vegetable Platter: Fried Eggplant, Creamed
 Broccoli, Buttered Spinach, Candied Sweet Potatoes,
 Roll and Butter 25

Bread, Rolls or Hot Milk Biscuits, Butter 05

VEGETABLES

Glazed Apples	10	Baked Beans (Pot)	10
Buttered Fresh Spinach	10	Baked Potato, Butter	05
French Fried Potatoes	10	Mashed Potatoes	10
Fresh String Beans	10	Fried Eggplant	10
Harvard Beets	10	Buttered Peas	10
Sauer Kraut	10	Candied Sweet Potatoes	10
Creamed Fresh Broccoli	10	Fresh Brussels Sprouts	10

BEVERAGES

Coffee 05	Cocoa 05		Tea 05
Milk (Bottle) 05	Hot Milk 10		Buttermilk 05
Vienna Chocolate 05		Chocolate Milk	10

Chocolate Milk Ice Cream Float 15
Gosman's Ginger Ale 10

Children's Dinners
25c
ROAST PRIME RIB OF BEEF
Mashed Potatoes, Gravy
OR
FRESH VEGETABLE PLATE
Buttered Spinach
Creamed Broccoli
Baked Potato

Buttered Roll

Rice Pudding, Vanilla Sauce
Egg Custard Pie
or Ice Cream

Milk, Vienna Chocolate or Tea

. . . Oysters . . .

Fried (6) 35,	(12)		70
Broiled on Toast (6) 40,	(12)	75	
Stew (Small) 30,	(Large)		45
Cream Stew (Small) 45,	(Large)	65	
Panned (Small) 30,	(Large)	60	
Pan Roast (Small) 35,	(Large)	65	

3 Fried Oysters, Pepper Hash 20,
 with French Fried Potatoes 25
Oyster Platter: 3 Fried Oysters,
 Cole Slaw, Sliced Tomato,
 French Fried Potatoes 30

We Make Our Own Pies, Cakes,
Pastries and Ice Cream

NDAY DINNERS

Choice

Chilled Fruit Cup

Tomato Juice Cocktail

Chicken Soup or English Beef Soup

TURKEY, Giblet Gravy	.85
Cranberry Sauce	
TEAK	.75
D HAM (Glazed Apples)	.65
CUTLET, Tomato Sauce	.60

Choice of Two Vegetables

Waldorf Salad

read or Hot Milk Biscuits and Butter

Tea Vienna Chocolate

Choice

dding, Sherry and Hard Sauce

Fresh Pumpkin Pie

Chocolate Eclair

yer Cake or Ice Cream

•

DESSERTS

ing, Vanilla Sauce	10
with Cream	15
ed Cream Layer Cake	10
hipped Cream	10
erry and Hard Sauce	10
Eclair 10 Cup Custard	10
eam 10 Chocolate Eclair	10
ocoanut Layer Cake 10	
Fresh Pumpkin, Hot Mince	
or Egg Custard	10
late Fudge, Maple Pecan, Pineapple	15
illa, Chocolate, Butter Pecan	10

MENU FROM THE HORN & HORN RESTAURANT IN BALTIMORE, 1940. A vintage menu, dated December 15, 1940, from the old Horn & Horn Restaurant reveals some amazing prices for quite an array of food selections, from appetizers to entrees to desserts. Oyster selections were plentiful as well. Waitress Claudia Coffey, known by everyone as Miss Coffey, came to the Pimlico Restaurant from the old Horn & Horn located across from the Gaiety Theater downtown. Coffey was precise and immaculate, arriving at the restaurant with her uniform pressed and starched, a practice that soon gave way to the Pimlico's more casual atmosphere. She developed the Coffey Salad, a chopped salad that she mixed and served herself, and it became her signature. Coffey ended her tenure there after 30 years when the restaurant closed in 1951. Many Jewish businessmen from Pimlico frequented the restaurant at its downtown location because they owned businesses in the area. Estelle Snyder Kahn remembers having New Year's dinner at the Horn & Horn. (Courtesy of Estelle Snyder Kahn.)

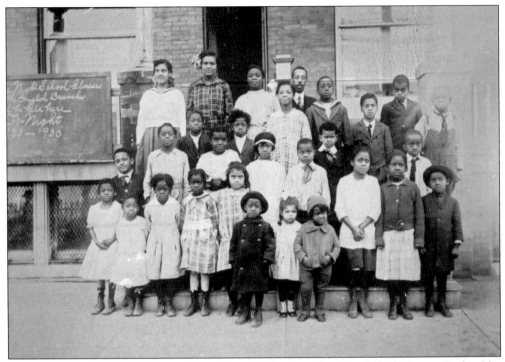

EARLY-20TH-CENTURY PIMLICO SCHOOL. This is a photograph of Dr. Alfred Monroe Bailey (the bearded gentleman standing in the back row) and his class at his school at Denmore and Payton Avenues in Pimlico. Pimlico was still part of Baltimore County prior to the 1918 "land grab." A blackboard on the left advertises night classes in English. (Courtesy of the Photograph Collection of the Baltimore County Library.)

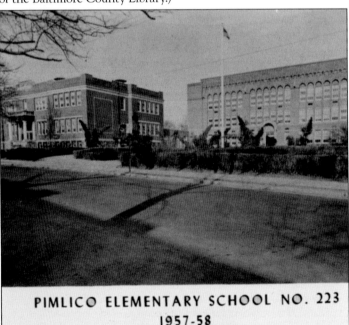

PIMLICO ELEMENTARY SCHOOL NO. 223
1957-58
Baltimore 15, Maryland

PIMLICO ELEMENTARY SCHOOL, 1957–1958. Baltimore City School No. 223, built in 1925 on Pimlico Road in Pimlico, is now called Pimlico Elementary/ Middle School and has an enrollment of 542 students from prekindergarten through the eighth grade and 41 teachers. Their goal is to be renamed the Pimlico Math and Science Academy. School colors are navy blue and yellow, its mascot is the stallion, and its motto goes as follows: "The Place of Academic Excellence." (Courtesy of Virginia Felter.)

PIMLICO ELEMENTARY SCHOOL FACULTY, 1958. This is a photograph of unidentified faculty members of the Pimlico Elementary School in 1958. Virginia "Ginny" Felter who attended the school recalled that her favorite teacher was Katherine Bush. Ginny was in the safety patrol and had fond memories of trips to New York and Washington, DC. (Courtesy of Virginia Felter.)

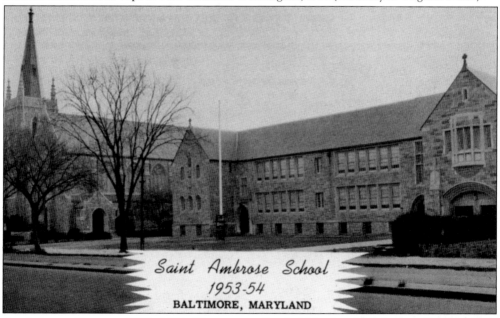

Saint Ambrose School
1953-54
BALTIMORE, MARYLAND

ST. AMBROSE SCHOOL, 1953–1954. Classes were first held in the old Suburban Hotel on Park Heights Avenue until a school was built in 1925. The school opened in 1926 with a teaching staff of eight Sisters of Notre Dame and Sr. Mary Josephine as principal. From 1972 to 1996, the school was a part of the Rosa Parks Inter-parish Schools. School restructuring in 1996 reinstated the name and parish identity, and today, the school serves 160 students in grades kindergarten through the eighth grade. (Courtesy of Virginia Felter.)

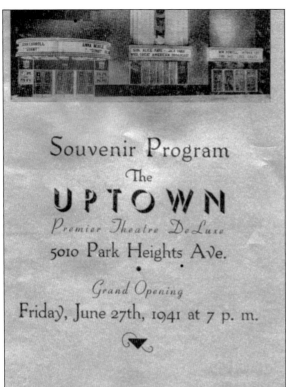

UPTOWN MOVIE HOUSE OPENING-NIGHT PROGRAM. The Uptown movie house opened on June 27, 1941, with Anna Neagle and John Carroll starring in *Sunny*. John F. Eyring, architect, designed the building in the Art Moderne style. Throughout the 1930s and 1940s, Rhea Wolf Offit managed the financial operations of the Uptown theater as well as the Pimlico and the Avalon. In 1974, it was operating on a reduced schedule, and by 1975, it had closed. Abe Snyder, known as "Mr. Pimlico," owned Snyder's Men's Wear next to the Uptown theater from 1925 to the 1940s. In addition to a upscale line of men's clothing, Kahn also carried jockey wear such as jodhpurs, boots, and silk colors for the stables at nearby Pimlico. The family lived above the store, and his daughter Estelle Snyder Kahn remembers dressing the windows of Snyder's. (Courtesy of Estelle Snyder Kahn.)

Eight

OLD PIKESVILLE

Like Pimlico, the area now known as Pikesville was also carved from the same land grant called Pemblicoe in 1699, owned by Capt. John Oldham of the Baltimore County Rangers. In 1695, Captain Oldham built Fort Garrison, a headquarters for a troop of mounted rangers charged with "patrolling the paths from the Pataspco to the Susquehanna as a protection against hostile Indians." In 1770, a Mr. Beacham built the first log house at Old Court Road and Reisterstown Turnpike; this small hamlet eventually had six or seven houses and evolved into the community of Pikesville. However, the community remained unnamed until 1771. Dr. James Smith, a medical doctor who became known as the father of vaccination due to this lifelong interest in the smallpox vaccine, named the area "Pikesville" after his dear friend who had served in the War of 1812, Brig. Gen. Zebulon Montgomery Pike (1779–1813).

In the early 1800s, Reisterstown Road figured into the transformation of Baltimore from a small port village into a bustling city. Farmers wanted a direct route for shipping wheat and corn to the Chesapeake Bay. In 1804, Maryland chartered a private group, the Baltimore and Reisterstown Turnpike Company, to operate, repair, and maintain the road from southern Pennsylvania into Baltimore City. Although, the road required regular upkeep and repair, it was still regarded as an excellent artery in and out of the city. In 1911, the State Roads Commission took it over and removed the tolls and the tollgate at present-day Park Circle.

In the early part of the 1900s, the influx of the Jewish population soon claimed Pikesville as their own community. They set up businesses, such as restaurants, delis, bakeries, clothing stores, and dry cleaning stores, and their own schools and synagogues. In the 20th century, Pikesville grew far beyond the boundaries that distinguished it as the small cluster community 100 years ago and today stretches much farther afield than the community of 1881.

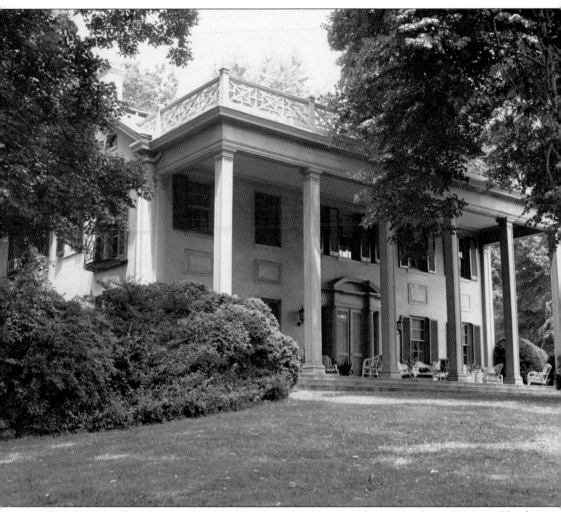

THE POMONA ESTATE OFF NAYLOR'S LANE IN PIKESVILLE. Abram Hutzler, son Moses Hutzler, purchased this estate in 1915. Moses Hutzler immigrated to America from the Bavarian town of Hagenbach in 1838. He opened a small dry goods store at the corner of Howard and Clay Streets in downtown Baltimore. At age 23, Abram opened his business, M. Hutzler & Son, in 1858 on Howard Street in downtown Baltimore. In 1867, Abram brought his two brothers Charles and David into the business. In 1880, the original building was razed and replaced with a five-story structure, the Hutzler Brothers Palace Building, designed by renowned architects Baldwin and Pennington. The business grew into a chain of 10 department stores. Hutzler's remained a family-owned Maryland business throughout its 132 years; all locations had closed by 1990. (Courtesy of the Photograph Collection of the Baltimore County Public Library.)

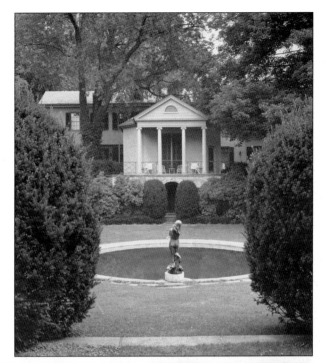

SIDE VIEW WITH FOUNTAIN AT THE POMONA ESTATE. With its excellent service and prestigious lines, "Hutzler's was the closest Baltimoreans got to Haute Couture," according to Daniel Sachs, who worked for Hutzler's for 24 years, from 1957 to 1981. In the early 1940s, a teenaged Joan Strouse sat on her front steps in Mount Washington waiting for a package on the Hutzler's delivery truck. Next-day or even same-day service was part of their policy. Daniel Sachs recalled that "the family treated us as part of their family, and as employees we were often invited to Albert Hutzler's Pomona estate." (Courtesy of the Photograph Collection of the Baltimore County Public Library.)

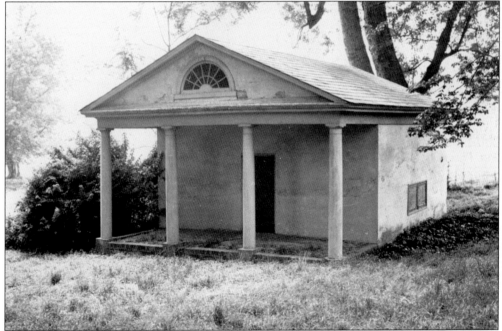

POMONA ESTATE SPRINGHOUSE. This Greek Revival springhouse was part of the Pomona estate. Abram Hutzler remained a bachelor, and after his death in 1927, his nephew Albert Hutzler Jr. bought the estate. When Mrs. Albert Hutzler died in 1977, her family sold the 90-acre estate and its herd of Black Angus cattle. The acreage has since been developed. Since 1842, the Hutzler family has remained involved in local religious, civic, and philanthropic affairs. (Courtesy of the Photograph Collection of the Baltimore County Public Library.)

SUDBROOK COTTAGE AT 506. James Howard McHenry (1820–1888) was one of Pikesville's largest landowners in the 19th century. Following his death in 1890, his widow, Sarah Nicholas Cary (1832–193), sold 204 acres of the 846-acre estate to the Sudbrook Company. Frederick Law Olmsted Sr., a landscape architect, was commissioned to design the area as a summer resort called Sudbrook Park. The community was placed in the National Register of Historic Places in June 1973. (Courtesy of the Photograph Collection of the Baltimore County Public Library.)

MCHENRY ESTATE, 1890. This is a photograph of a room, most likely the parlor, at the Sudbrook estate, the home of James Howard and Sarah Nicholas McHenry. McHenry, grandson of a former US secretary of war (and for whom Fort McHenry was named), acquired the property from Alexander Riddle for $2,531.25. The ornate Victorian decor is representative of that time period. (Courtesy of the Photograph Collection of the Baltimore County Public Library.)

SUDBROOK METHODIST CHURCH. In 1894, Charles F. Diggs and his wife, Camille, donated the land for this church, designed by Philip Watts and his son Albert, architects and builders. It was to be a frame Gothic structure with a steeple 100 feet high; it cost $6,650. The cornerstone of the church was laid in the fall, and a year later, the church building was dedicated on October 20, 1895. (Courtesy of the Photograph Collection of the Baltimore County Public Library.)

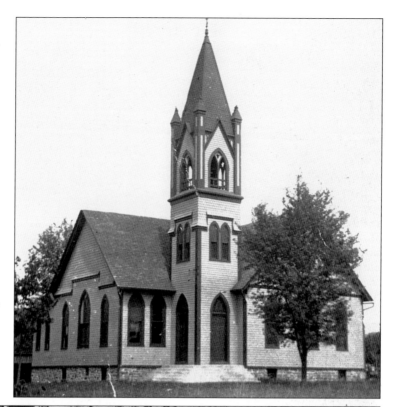

THE SUDBROOK PARK. The Sudbrook Company purchased 204 acres from James Howard McHenry's 846-acre Sudbrook estate in Pikesville after McHenry's death in 1890. Frederick Law Olmsted Sr. was commissioned to design a summer resort called Sudbrook Park. The community was placed in the National Register of Historic Places in June 1973. This house at 506 Sudbrook Road is located in Sudbrook Park. (Courtesy of the Photograph Collection of the Baltimore County Public Library.)

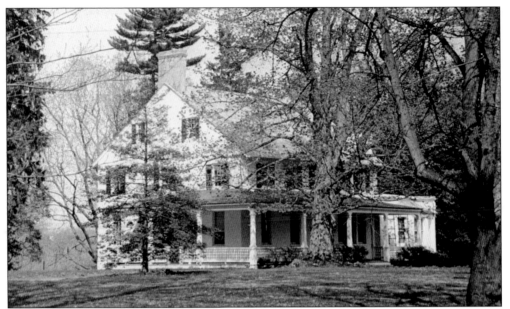

ANNANDALE. Nelson Morris, a merchant of Baltimore, and his wife, Sarah Carnan, first lived at Annandale, a 600-acre estate in Pikesville. In 1870, the house, along with 222 acres, was sold to Charles Harrison and his wife, Louis Triplett Haxall. Harrison founded the Pikesville dairy in 1871 with several neighboring farmers. Before 1911, Annandale was sold and became Druid Ridge Cemetery, and the old house became the cemetery superintendent's home. (Courtesy of the Photograph Collection of the Baltimore County Public Library.)

DRUID RIDGE CEMETERY OFFICE. The cemetery was dedicated on June 11, 1898, on what had been Charles K. Harrison's Annandale estate. The price of plots that year ranged from $38 for 100 feet for three graves to $412 for 400 feet for 12 graves. This stone building on Reisterstown Road was the office for Druid Ridge until it was demolished in 1959. (Courtesy of the Photograph Collection of the Baltimore County Public Library.)

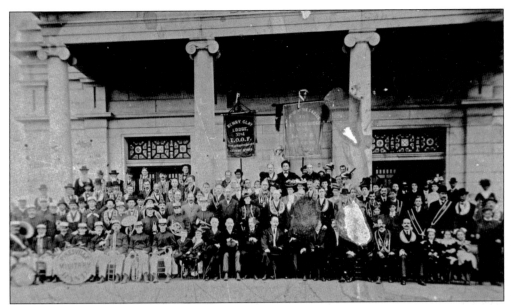

PIKESVILLE MILITARY BAND. This band was originally called the Citizen's Comet Band until it changed its name in 1914, although there was nothing military about the band except the uniforms. The men practiced every Thursday night in the Odd Fellows Hall and played patriotic music for the Odd Fellows when they decorated the graves of veterans buried in Druid Ridge Cemetery. The Mausoleum at Druid Ridge is in the background. (Courtesy of the Photograph Collection of the Baltimore County Public Library.)

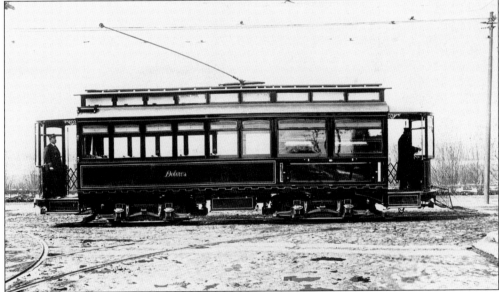

A STREETCAR NAMED "DOLORES." This is the "Dolores" funeral streetcar, rebuilt from a Baltimore & Northern passenger car about 1900. This conveyance, which carried casket, pallbearers, and family, traveled to cemeteries all over Baltimore, including Druid Ridge. The rental fees, including conductor and motorman, were $20 within the city limits and $25 to the suburbs. At Druid Ridge, a horse-drawn conveyance took the casket to the burial site. (Courtesy of the Photograph Collection of the Baltimore County Public Library.)

ARMORY. The cornerstone of the Pikesville Armory was laid in 1903. This image shows the entrance gateway of the Pikesville Armory off Reisterstown Road. The gateway is a memorial to those who served in World War I. The armory originally served as a cavalry unit, with a riding hall and stabling provisions. The 1st Battery of the 110th Field Artillery of the Maryland National Guard was organized here in 1915 and was still there 75 years later. (Courtesy of the Photograph Collection of the Baltimore County Public Library.)

CAVALRY UNIT. A cavalry unit, organized in 1897, took possession of the new armory quarters on 13 acres of land in Pikesville. The new quarters were complete with an indoor riding hall and stables and housed a horse-drawn cannon unit. Troops trained in Pikesville left from the Howardville station on September 16, 1917, for Camp McClellan in Alabama. These troops served overseas during World War I. (Courtesy of the Photograph Collection of the Baltimore County Public Library.)

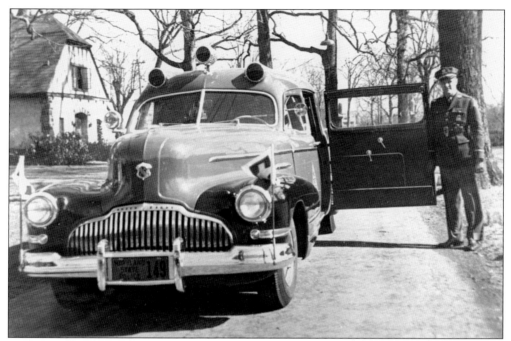

VINTAGE AMBULANCE. George E. Davidson, Maryland state police trooper (and later lieutenant colonel and acting superintendent), proudly stands next to the 1941 ambulance at Pikesville Armory headquarters. (Courtesy of the Photograph Collection of the Baltimore County Public Library.)

POLICEMEN, C. 1941. Maryland state policemen are shown here in the cafeteria of the armory. Maryland State Police headquarters was originally located on Guilford Avenue in Baltimore City until it moved to the 1816 armory complex in the 1940s. (Courtesy of the Photograph Collection of the Baltimore County Public Library.)

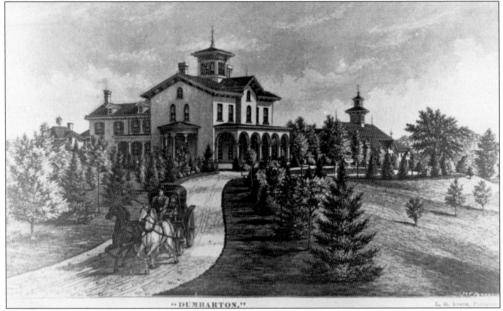

DUMBARTON. This is an engraving of Dumbarton, a 16-room Victorian stone mansion built by Noah Walker, a Baltimore clothier, in 1860 as a wedding present for his son Patrick. During Patrick's time, Dumbarton was a flourishing farm with 600 head of cattle and fields for raising wheat, corn, hay, and oats. In 1893, the property was sold to John and Mary Waters for $100,000. In 1897, Waters sold off portions of the estate, including 20 acres for a clubhouse at the new Suburban Club of Baltimore, built in 1902. (Courtesy of the Photograph Collection of the Baltimore County Public Library.)

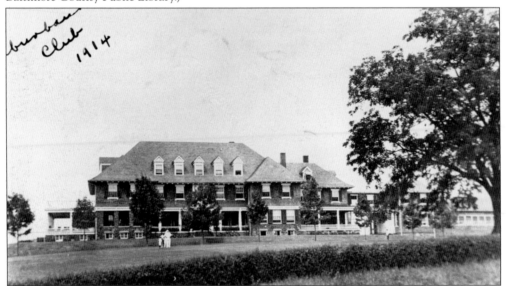

THE SUBURBAN CLUB, C. 1914. This club is located at the corner of Park Heights Avenue and Slade Avenue in Pikesville. It was established in 1903 by members of the affluent German Jewish community on land leased from Thomas Beale Cockey of neighboring Lyal Park. This building was razed and a new one erected in 1960. (Courtesy of the Photograph Collection of the Baltimore County Public Library.)

A Great Day for Golf. Two golfers can be seen enjoying a day on the links at the Suburban Club of Pikesville. The old clubhouse of 1903 was razed and replaced by the structure seen in the background of this 1960 photograph. The course was originally 9 holes and was later expanded to 18 holes. (Courtesy of the Photograph Collection of the Baltimore County Public Library.)

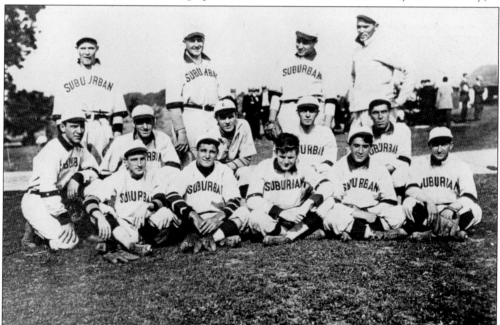

Suburban Club Baseball Team, c. 1912. Unidentified members of the Suburban Club baseball team in Pikesville pose for a team photograph. It is not known whether these players were members of the club or just chose the name "Suburban" for their team name. (Courtesy of the Photograph Collection of the Baltimore County Public Library.)

CORBETT'S GENERAL STORE, C. 1910. Timothy Corbett opened Corbett's General Store, complete with elevator, at the corner of Reisterstown and Walker Avenues in Pikesville. Corbett was a Southern sympathizer and spent time at Fort McHenry. After contracting pneumonia, he was released and sent home. His son Robert inherited the business in 1852, and the store continued in operation until World War II. (Courtesy of the Photograph Collection of the Baltimore County Public Library.)

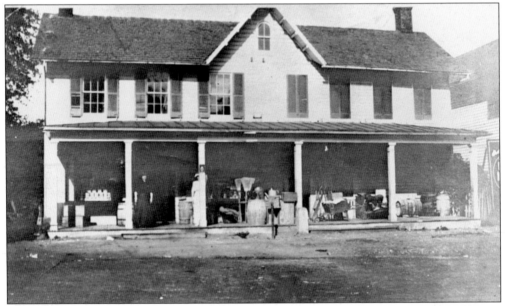

FOLEY'S STORE, 1890. William Foley, an Irish immigrant, ran a general store in Pikesville. His naturalization papers were dated August 27, 1857, about the same time he established the store. The store carried everything from dried beans to molasses and brooms to barrels. The Foley store also delivered orders in a horse-drawn delivery wagon. (Courtesy of the Photograph Collection of the Baltimore County Public Library.)

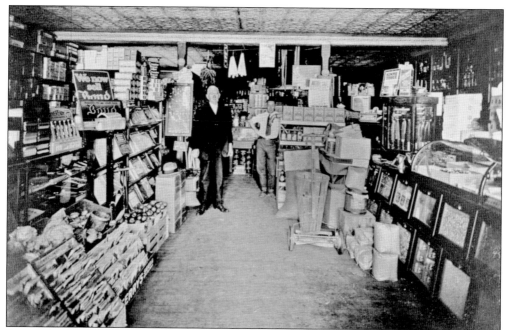

FOLEY'S STORE INTERIOR, 1900s. This interior view of Foley's Store in Pikesville shows an elderly Timothy Foley with young assistant John McGuire. Note the old-fashioned metal ceiling and the manner in which cookies and crackers were stored on the right. (Courtesy of the Photograph Collection of the Baltimore County Public Library.)

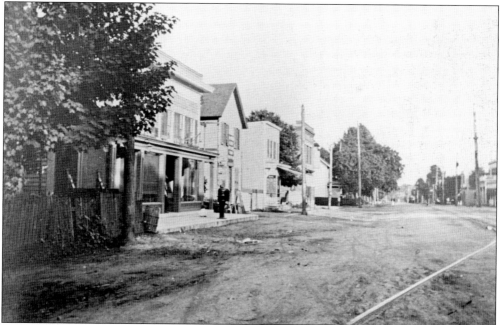

FOLEY'S FEED STORE, C. 1890. The feed store was located next to Foley's Store on Reisterstown Road in Pikesville. An unidentified man and woman are shown standing in front of the store. The sign advertises some of the merchandise sold at the store. (Courtesy of the Photograph Collection of the Baltimore County Public Library.)

THE PIKESVILLE NATIONAL BANK. The Pikesville National Bank, chartered in 1907, transacted business in a room at the Burnt House Tavern (shown on the right) until 1909. The bank stood at the corner of Reisterstown and McHenry Roads, sometimes called Bank Lane. The first president was Paul Seeger, and the first cashier was Charles Hann. The bank's telephone number was 1. (Courtesy of the Photograph Collection of the Baltimore County Public Library.)

TAMBURO'S DRUGSTORE, C. 1950. This drugstore was located at the corner of Slade Avenue and Reisterstown Road. The building was razed to make way for a large office structure. This is a view of Slade Avenue before banks lined two sides of the road and the third side became a large public parking lot. (Courtesy of the Photograph Collection of the Baltimore County Public Library.)

FIELDS PHARMACY. Dr. William Fields opened the original Fields drugstore in 1892. After his death, his wife continued to run the business with her sons Tommy and Lorain. The face of the store was changed in 1935 when the original porch was enclosed to make more room. In 1946, Dr. Norman Levin took over the business, and in 1957, the Medical Center at the corner of Walker Avenue was added. Dr. Levin died in 1975, and his wife, Ruth Hollander, and son Jeffrey became the new owners. In 1998, the pharmacy stopped operating, but customers still continued to patronize the lunch counter and the store's impressive cosmetics department. In 2012, Fields closed its doors after 120 years of continuous operation. The store with its lunch counter was a longtime gathering spot for Pikesville residents. (Courtesy of the Photograph Collection of the Baltimore County Public Library.)

McGuire's Florist Business. Albert L. McGuire ran a florist business on Reisterstown Road on the property he purchased from William Keir in 1923. The small stone house was built in the days of horse traffic on the turnpike in the 18th and early 19th centuries. In 1972, the greenhouses and house were demolished to make way for progress—a gas station. (Courtesy of the Photograph Collection of the Baltimore County Public Library.)

McGuire's Delivery Van. An unidentified man (possibly Albert McGuire) stands in front of a McGuire Florist delivery truck. The business, owned by Albert L. McGuire, was located on Reisterstown Road from 1923 until 1972, when the shop was demolished. (Courtesy of the Photograph Collection of the Baltimore County Public Library.)

PURCELL JEWELER DELIVERY SERVICE. R.L. Purcell, jeweler, owned a store in the 1300 block of Reisterstown Road across from Pikesville Elementary School. This 1912 Ford motorcar was fitted up with a large black carrying box. On Mondays, Purcell offered home delivery and pickup service to clients in the Pikesville and Green Spring Valley areas. He wound clocks, examined silverware, and took items back to his shop. (Courtesy of the Photograph Collection of the Baltimore County Public Library.)

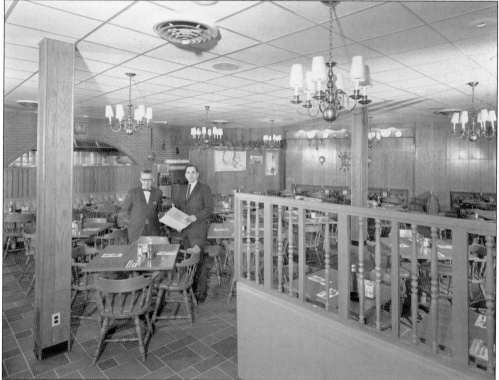

THE SUBURBAN HOUSE. Suburban House, now located in Pomona Square in Pikesville, is a landmark restaurant that has been in business for over 45 years. In 2009, its previous location in downtown Pikesville was destroyed by fire. It still retains its reputation as an old-fashioned, hospitable, and highly frequented diner under the ownership of Joe Stowe and Mark Horowitz. (Courtesy of the Photograph Collection of the Baltimore County Public Library.)

THE BLUE CREST NORTH RESTAURANT. Philip Bluefield, president of Bluefield Caterer, opened the Blue Crest North Restaurant at 401 Reisterstown Road in 1959. Bluefield Caterer handled political, social, and charitable gatherings at its own halls as well as serving food in armories and tents. There was also a carryout shop there called Butler's Pantry. (Courtesy of the Photograph Collection of the Baltimore County Public Library.)

PIKES THEATER. This theater at 921 Reisterstown Road was designed by John Eyring, who was noted for this design of local theaters in the Art Deco theme. The theater opened in 1937 and closed in the 1970s. In the late 1990s, the theater reopened and included a store and restaurant. Currently, Pikes Diner, a theater-themed diner, occupies the space, and local media has reported owner Wil Reich will revive the Pikes Theater. (Courtesy of the Photograph Collection of the Baltimore County Public Library.)

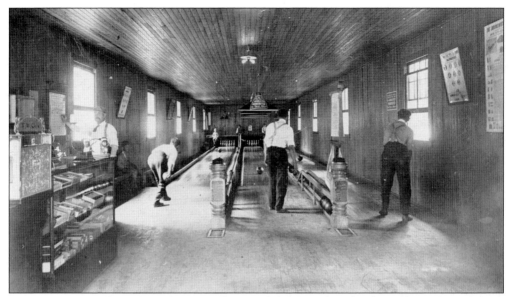

Bowling Alley. The Cox family originally owned this three-lane bowling alley on Reisterstown Road and Sudbrook Lane in Pikesville. Frank Spalding acquired it in 1933, and after the Prohibition repeal, he obtained a liquor license and added a bar. During Word War II, the Spaldings changed the renovated business from a bar into a restaurant. The restaurant closed by the end of the 20th century. (Courtesy of the Photograph Collection of the Baltimore County Public Library.)

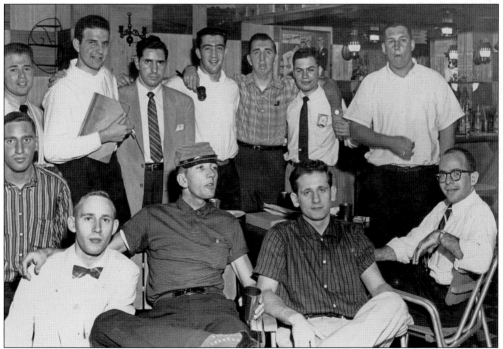

Favorite Pastimes, 1950s. Gerry Yarmin snapped this photograph of the guys hanging out at one of their homes near Forest Park. Their favorite pastimes were playing pool, double dating, and going to the Hilltop Diner. Shown in the picture are Charlie Anello, Marty Toukoff, Al Shapiro, Lee Samuelson, and eight unidentified men. (Courtesy of Gerald Yamin.)

FIRST SCHOOLHOUSE. The first public schoolhouse in Pikesville was built in 1859 on what became Schoolhouse Lane at Walker Avenue. A brick addition was added in 1879, and a second brick structure was added in 1897. The school was closed when the new Pikesville Elementary School was built in 1914. It became a private residence and later an apartment building. (Courtesy of the Photograph Collection of the Baltimore County Public Library.)

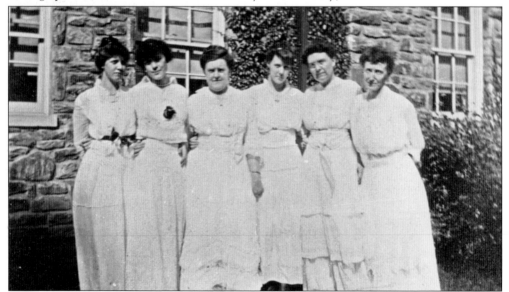

PIKESVILLE TEACHERS, C. 1920. This is a photograph of six Pikesville Elementary School teachers taken in front of the new school that opened in 1914. At that time, the school was located at Slade Avenue and Schoolhouse Lane. The teachers are identified as follows: Ella Smith, principal; Margaret Coe, Florence (Hall) Emrich, Lillian Earp, Lottie (Church) Armstrong, and Isabel Disney. (Courtesy of the Photograph Collection of the Baltimore County Public Library.)

PIKESVILLE LIBRARY. The new Pikesville branch of the Baltimore County Public Library at 1301 Reisterstown Road was built on the site of the demolished Pikesville Elementary School and opened on February 14, 1982. (Courtesy of the Photograph Collection of the Baltimore County Public Library.)

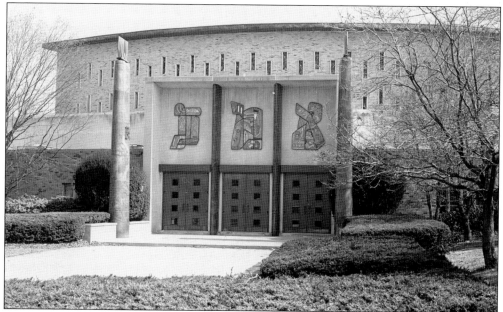

BETH EL SYNAGOGUE. This conservative Jewish synagogue was organized in 1947, and the group originally met in the Community Hall on Liberty Road until 1950. The congregation moved to its present site of 16 acres of land at 8101 Park Heights Avenue in 1960. H. Bruce Finkelstein and Benjamin Brotman are credited with designing the structure. (Courtesy of the Photograph Collection of the Baltimore County Public Library.)

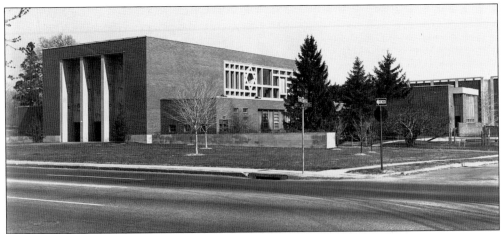

REFORM TEMPLE OF THE BALTIMORE HEBREW CONGREGATION. The Baltimore Hebrew Congregation was granted a charter in 1830 and moved to this 16-acre site at 7401 Park Heights Avenue in 1951. The Baltimore Hebrew Congregation is a leader in the Reform Movement, offering an extensive variety of social, spiritual, and educational opportunities. The Baltimore Hebrew Congregation is the largest reform congregation in the Baltimore area. (Courtesy of the Photograph Collection of the Baltimore County Public Library.)

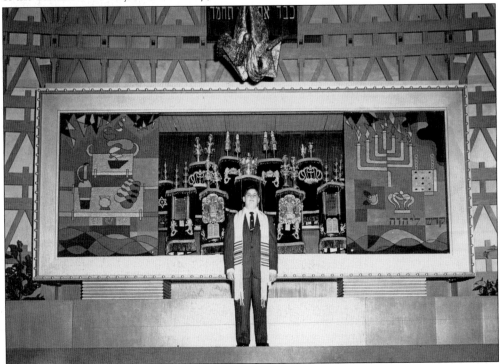

BAR MITZVAH. This is a photograph of an unidentified young man standing on the bema (stage) with the ark (altar) behind him that holds the Torah. A Jewish boy becomes a Bar Mitzvah (meaning "son of the commandment") upon reaching the age of 13 years. It marks the first time that a young man reads from the Torah (the old testament), usually in the form of scrolls. After reading from the Torah, he is allowed to participate in various religious practices. (Courtesy of Gerald Yamin.)

MENORAH. A unidentified young man stands next to this seven-candle menorah that appears in the synagogue. It is distinguishable from a Hanukah menorah by the number of candles. The Hanukah menorah has nine candles, one candle for each night of the eight nights of Hanukah, with the last candle being used to light the others. (Courtesy of Gerald Yamin.)

A Family Affair. In modern times, the religious service for Bar Mitzvahs (boys) and Bat Mitzvahs (girls) is followed by a reception that is often as elaborate as a wedding reception. Family members and friends share in the celebration. The service does not mark the end of a Jewish education but stresses the importance of studying the Torah throughout their lives. Some rabbis require their students to sign an agreement to continue Jewish education after their Bar or Bat Mitzvah. (Courtesy of Gerald Yamin.)

St. Mark's on the Hill, 1880. This is a photograph of the first wooden St. Mark's on the Hill Episcopal Church at 1620 Reisterstown Road in Pikesville. A deed for three-quarters of an acre was conveyed to Charles T. Cockey on April 16, 1877, from the McHenry family. The deed stated that the site was always to be used as a place of worship, or it would revert to McHenry ownership. The church was named St Mark's on the Hill, as suggested by Louise Harrison, wife of Charles K. Harrison; the couple was responsible for establishing the church. (Courtesy of the Photograph Collection of the Baltimore County Public Library.)

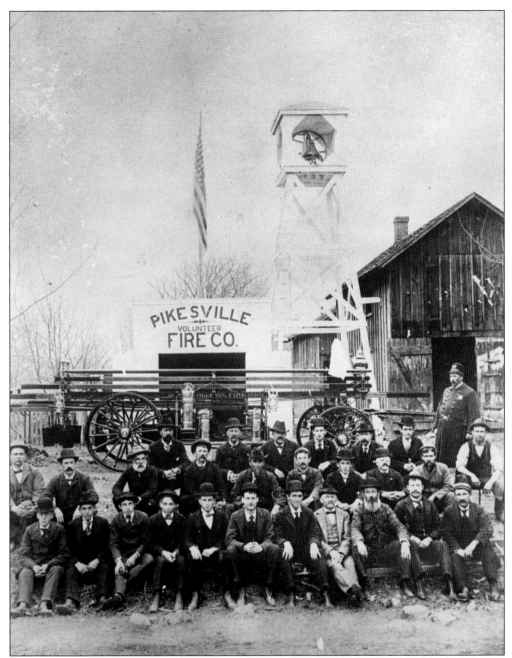

PIKESVILLE FIREHOUSE. The first firehouse of the Pikesville Volunteer Fire Company was located at Reisterstown Road and Sudbrook Lane. In 1921, the company moved from Foley's Lane to this location. This photograph shows the station crew seated in front of a Holloway ladder truck with a chemical extinguisher. (Courtesy of the Photograph Collection of the Baltimore County Public Library.)

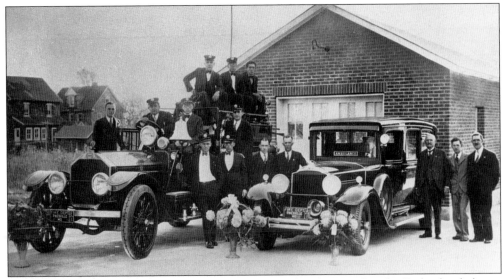

STATION CREW, 1930. Pikesville volunteer firemen pose in this photograph with a Packard ambulance. On top of the 1915 American LaFrance 500-gallons-per-minute engine are Monroe Shipley, Harry Hartman, and Ed Crunkilton. Others in the photograph are, from left to right, Edward Irwin, Sam Zito, Albert Clautice, Clarence Purcell, Clay Purcell, Victor Sollers, Joseph Caughy, Arthur Shipley, Glen Watts (driver), Frank Given (county commissioner), William Messersmith, and William Smith. (Courtesy of the Photograph Collection of the Baltimore County Public Library.)

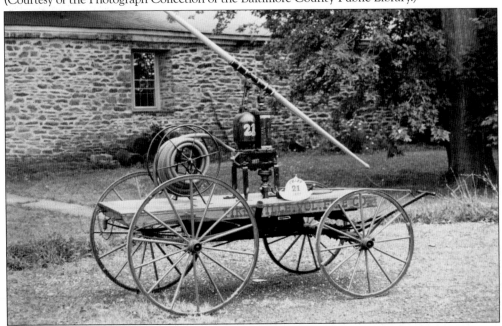

OLD PUMPER, C. 1890. This Gould hand-pumper, Engine No. 21, is owned by the Pikesville Volunteer Fire Company. It was mounted on a spring wagon that carried a hose and other firefighting equipment. Though generally pulled by hand, horses sometimes were requisitioned from local merchants or farmers to pull it. The vintage equipment was retired in 1939 but is proudly displayed at parades and social functions. (Courtesy of the Photograph Collection of the Baltimore County Public Library.)

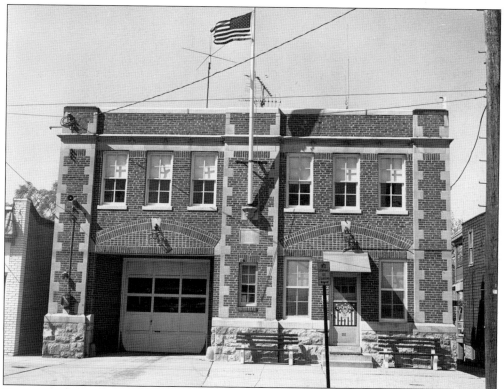

PIKESVILLE FIRE AND POLICE DEPARTMENTS. In 1920, G. Walter Tovell designed this building on Reisterstown Road for the Pikesville Fire and Police Departments. A two-room jail, one for men and one for women, was located at the back of the building. By 1962, the police department had left, and in that same year, the fire volunteers moved to a new building on Sudbrook Lane. (Courtesy of the Photograph Collection of the Baltimore County Public Library.)

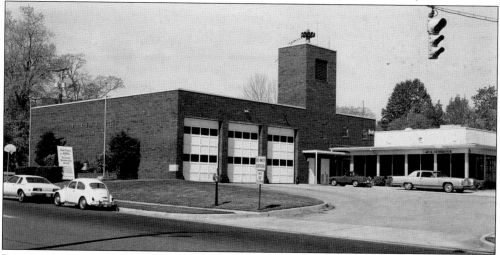

PIKESVILLE VOLUNTEER FIRE DEPARTMENT. In 1962, the volunteer fire department, whose numbers had grown too large to share quarters with the paid fire department, moved to this building at 410 East Sudbrook Lane in Pikesville. In 1964, the paid department moved from Pikesville to Garrison. (Courtesy of the Photograph Collection of the Baltimore County Public Library.)

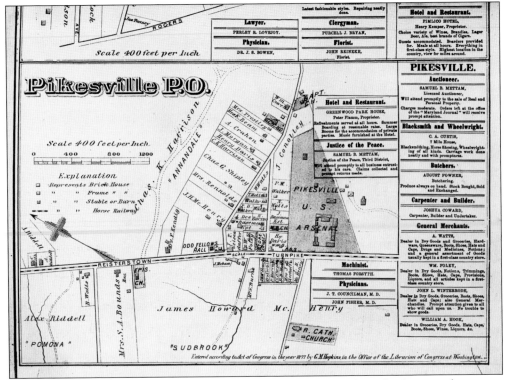

EARLY MAP OF PIKESVILLE, C. 1877. This is a detailed map of Pikesville showing the estates of McHenry in Sudbrook, Ridell in Pomona, and Harrison in Annandale. Also shown are the locations of Mettam Baptist Church, the Roman Catholic church, and Foley's Store. Prominently displayed in the right middle distance is the building layout of the US Arsenal, which subsequently became the Confederate Soldiers Home and later Maryland State Police headquarters. (Courtesy of the Photograph Collection of the Baltimore County Public Library.)

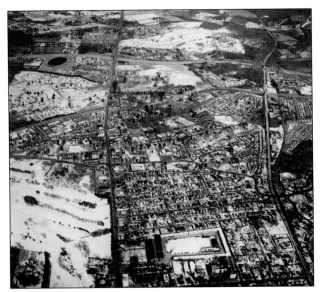

AERIAL VIEW OF PIKESVILLE. This is a later aerial view of sprawling Pikesville. The roads running north and south are Reisterstown Road on the left and Park Heights Avenue on the right. This prosperous Baltimore suburb with over 200 years of history is now a vibrant, progressive community with a reputation for high quality and luxury. Pikesville also features a thriving business community of retail and professional services. The 2010 census listed a population of over 30,000 people and 13,000 households in the area. (Courtesy of the Baltimore Museum of Industry.)

BIBLIOGRAPHY

Frank, Beryl. *A Pictorial History of Pikesville, Maryland*. Towson, MD: Baltimore County Library, 1982.

Kelly, Jacques. *The Pratt Library Album: Baltimore Neighborhoods in Focus*. Baltimore, MD: Enoch Pratt Free Library, 1986.

Miller, Mark. *Mount Washington, Baltimore Suburb: A History Revealed through Pictures and Narrative*. Baltimore, MD: GBS, 1980.

Powell, W.S. *Mount Washington: What It Was, What It Is, and What It Ought to Be."* Mount Washington, MD: 1885.

Ryon, Roderick. *Northwest Baltimore and Its Neighborhoods, 1870–1970: Before "Smart Growth."* Baltimore, MD: University of Baltimore, 2000.

Sandler, Gilbert. *Jewish Baltimore: A Family Album*. Baltimore, MD: Johns Hopkins University Press, 2000.

Todd, Dr. William J. *Picturesque Mount Washington*. 1900.

Weston, B. Latrobe. *The Story of Mount Washington, Maryland*. Baltimore, MD: 1948.

DISCOVER THOUSANDS OF LOCAL HISTORY BOOKS FEATURING MILLIONS OF VINTAGE IMAGES

Arcadia Publishing, the leading local history publisher in the United States, is committed to making history accessible and meaningful through publishing books that celebrate and preserve the heritage of America's people and places.

Find more books like this at
www.arcadiapublishing.com

Search for your hometown history, your old stomping grounds, and even your favorite sports team.